Creating the
Musée d'Orsay

Andrea Kupfer Schneider

CREATING

—⟫•⟪— *the* —⟫•⟪—

Musée
d'Orsay

The Politics of
Culture in France

The Pennsylvania State University Press
University Park, Pennsylvania

Library of Congress Cataloging-in-Publication Data

Schneider, Andrea Kupfer.
 Creating the Musée d'Orsay : the politics of culture in France /
Andrea Kupfer Schneider.
 p. cm.
 Includes bibliographical references and index.
 ISBN 0-271-01752-X (alk. paper)
 1. Musée d'Orsay. 2. Art and state—France. 3. France—
Cultural policy. I. Title.
 N2050.077S36 1998
 708.4'36—dc21 97-29711
 CIP

It is the policy of The Pennsylvania State University Press to use acid-free
paper for the first printing of all clothbound books. Publications on
uncoated stock satisfy the minimum requirements of American National
Standard for Information Sciences—Permanence of Paper for Printed
Library Materials, ANSI Z39.48-1992.

Contents

In honor of Mama and Papa,
Mildred and Joseph Stern

Acknowledgments

In a project that has taken me from student to professor, there are numerous people to thank for their advice, guidance, and comments. Let me start with my professors at Princeton University: Arno Mayer, who first gave me the idea of researching the Musée d'Orsay; Philip Nord, who served as my thesis advisor; and Andre Maman and Anthony Vidler, who gave me assistance in securing interviews for researching this book. Many sources at Princeton contributed to the funding of my research in 1988. The Class Funds of 1934, 1939, and 1942, as well as the History Department, Regional Studies Department, and the Dean of the College were very generous in their support.

While researching this book, I interviewed numerous parties involved with the creation of the Musée d'Orsay. My appreciation goes to M. Georges Beck, Conseiller Technique to Jack Lang, former Minister of Culture; Mme. Michèle Champenois, journalist for _Le Monde_; M. Pierre Colboc, architect and partner in ACT Architecture; M. Jean Coural, director of Mobilier National; M. Jean Jenger, director of Documentation Française and former director of the Établissement Public of the Musée d'Orsay; Mme. Geneviève Lacambre, head curator of the Musée d'Orsay; Mme. Mariani-Ducray, Conseiller Technique in charge of national museums to François Leotard, former Minister of Culture; M. George Monni, Cultural Service of the Musée d'Orsay;

M. Dominique Ponau, director of the École du Louvre and of the École du Patrimoine; Mme. Madeleine Rebérioux, former vice-president of the Établissement Public of the Musée d'Orsay; M. Pierre Vaisse, professor and art historian at University of Paris X; and M. Henri Zerner, professor and art historian at Harvard University. In particular, M. Colboc, M. Jenger, and Mme. Rebérioux were very generous with their time and information. Mme. Huguette Épinat of the Presse-Relations Publique at the Musée d'Orsay was extremely helpful in providing access to the press clippings collection regarding the museum.

I would like to thank Professor Stanley Hoffman of Harvard University for his encouragement in publishing this work. The University of Pennsylvania Law School and Dean Colin Diver provided office space and support during the spring of 1993 while I worked on the manuscript. Denise Hunter, my assistant at Marquette University Law School, has also been invaluable in bringing this project to its fruition.

For their insightful comments and suggestions, I would like to thank Cynthia Field of the Smithsonian Institution, Ranee Katzenstein of Los Angeles, Stephen Weil of the Hirshhorn Museum, and Harvey Feigenbaum of George Washington University, as well as the anonymous reviewers from Penn State Press. Each of them helped make the book stronger and clearer. Any faults that remain no doubt occur from not following their suggestions more closely. I would also like to thank Philip Winsor, my editor at Penn State Press, who was steadfast in his support of this project for many years, and Patricia Mitchell, my copyeditor, for her helpful edits.

I am extremely grateful to Elisabeth Molle, of the Service Photographique de la Reunion des Musées Nationaux, for her untiring assistance in procuring the lovely photographs in this

book, and to Jean-Paul Philippon, for providing the interesting architectural drawings of the Musée d'Orsay.

Last, I would like to thank my extended family, who have supported this project in a variety of ways. Shelly Kupfer and Ellen Frank both provided invaluable editorial assistance. I owe a special debt of gratitude to my mother, Barbara Burstin, who first took me to Paris, and on another trip, sat with me in the café at the Musée d'Orsay and reinvigorated my effort to tell this wonderful story. And to my husband Rodd, my thanks and appreciation for his love and unwavering support.

Introduction

The Gare d'Orsay is superb and has the air of a palace of Beaux-Arts while the Palace of Beaux-Arts resembles a station. I propose to Laloux to do an exchange if there is still time.

—Edouard Détaille

French painter Edouard Détaille's reaction to the Gare d'Orsay is understood clearly by any visitor to the Musée d'Orsay.[1] The building that houses the Musée d'Orsay originally opened in 1900 as the Gare d'Orsay train station. Designed by French architect Victor Laloux (1850–1937), the Gare d'Orsay was hailed by many architects and art critics as an architectural triumph. Eighty-six years after the opening of the Gare d'Orsay, the French government finally acceded to Détaille's request and transformed the Gare d'Orsay into the Musée d'Orsay.

While the decision to place nineteenth-century art in the nine-teenth-century building appears to be a logical one, the story of the creation of the Musée d'Orsay is much more complex. By the time the Musée d'Orsay opened in December 1986, two ar-chitectural teams, three different presidents of France, and an even greater number of cultural ministers had overseen the project. In 1986, France had a government of "cohabitation"—shared political power between two coalitions—for the first time in its history. Socialist president François Mitterrand had been forced to appoint conservative Paris mayor Jacques Chirac as prime minister after the 1986 elections. Yet, while the world centered its attention on the problems of two political parties working together, the museum had in effect already resolved those prob-lems. The Orsay was hailed as the "triumph of cohabitation."[2]

By focusing too closely on how well the political parties worked together, however, one overlooks the real centers of debate in the creation of the museum. The creation of the Musée d'Orsay is actually the story of three battles: one over architecture, one over art history, and one over cultural policy.

Many questions fueled these battles. Should a nineteenth-century building be saved or destroyed? Should its interior be decorated in a Beaux-Arts style or a modern design? What pe-riod or periods should the museum encompass? Should both academic and avant-garde art be shown in the museum? How should the collection be organized? Is the museum concerned with the artistic concerns of the elite or the masses, with high culture or popular culture? Should history be taken into in an art museum? How broad is the definition of high art? The pro-cess of answering these questions drew the battle lines and made the museum a centerpiece of debate. *New York Times* critic Michael Brenson wrote in 1988, "The Musée d'Orsay may be

only a little more than a year old, but it is already the most controversial museum built this decade."[3]

The existence, approach, and style of the museum were the subjects of vocal press reviews. The media was not indifferent to the museum; reviews either praised it or damned it. Conservative critics argued that the modern interior architecture of the Musée d'Orsay rejected, as well as hid, the original nineteenth-century style of the Gare d'Orsay. The Musée d'Orsay displayed numerous works of art, known as academic or salon art, which had been originally approved by the French Academy to be shown in the Salon.[4] In light of the popularity of Impressionist and later modern art in the twentieth century, much of this salon art had been removed from public view in museums and put in storage. While conservative critics of the museum were pleased to see salon art displayed, they complained that it was not sufficiently represented. The Musée d'Orsay, in the eyes of these critics, was only the beginning of a long-overdue rehabilitation of academic art. Furthermore, any attempts to bring history into the museum or mimic the more modern Pompidou Center were discouraged.

From the left, critics were equally vocal. The postmodern interior was hailed as a sign of the 1980s. But at the same time the curators were assailed for reinterpreting history and mutilating aesthetic taste by displaying salon art in the museum. Although the attempt to bring more people into the museum was lauded, the extreme left still believed the museum was elitist. The claims and counterclaims can be understood only through an examination of the decisions made regarding the museum, how these decisions were reached, who made these choices, and which commentator was discussing the museum.

A study of the decision-making process behind the creation of the Musée d'Orsay is as revealing as was its completion. The

decisions made over the building, design, and contents of the museum reflect how government functions and who holds the power in French society. Was it Giscard d'Estaing, who launched the museum in 1978, or François Mitterrand, who became president in 1981 with plenty of time to overturn the previous decisions? Was it the elected government of France or the curators of the museum?

The actors in this drama were pitted against one another: Giscard d'Estaing against François Mitterrand; the young French architectural firm ACT against an established Italian architect, Gae Aulenti; museum curators, led by Michel Laclotte, the head of painting at the Louvre who was appointed to serve also as the chief curator of the Orsay, and Françoise Cachin, a curator at the Pompidou Center appointed to serve as the director of the Orsay, all against Madeleine Rebérioux, a social historian appointed by the Socialist government to bring history into the museum. Refereeing these battles was the government-appointed body overseeing the creation of the museum, the Établissement Public, directed by Jacques Rigaud and Jean Jenger. Michel Laclotte himself stated, "A museum is not, and can never be, a coldly constructed encyclopedia, signed, sealed, and delivered. It is bound to reflect the tastes and preferences of the people responsible for the gradual construction over the years."[5]

A reading of the Orsay "encyclopedia" reveals the tastes and preferences of the actors that are referred to by Michel Laclotte. Hirshhorn Museum deputy director and law professor Stephen Weil has written that "the real issue is not how to purge the museum of values . . . but how to make those values manifest. [The museum] transmit[s] messages, too, and it seems to me vital that we understand better just what those messages are."[6] The ultimate message from the Orsay is the result of each com-

promise and the process by which that compromise was reached. Through decoding that message, the values of the French government, the museum administration, and the French people are also revealed.

Administrative History and the Architectural Debate

As a career, being the architect for a major Parisian project is about as secure as being a gladiator in ancient Rome, so inextricably linked is architecture with politics in France.
 —Charlotte Ellis, 1986

I believe that a people are great when their architecture is great. —François Mitterrand, 1987

From the Gare d'Orsay to the Musée d'Orsay

When the Musée d'Orsay opened in December 1986, it had been forty-seven years since the building had been used as a train station.[1] The lull in use from 1939 to 1986, however, was not the first time that the government had difficulties finding a purpose for this site on the left bank of the Seine. The Palais d'Orsay was

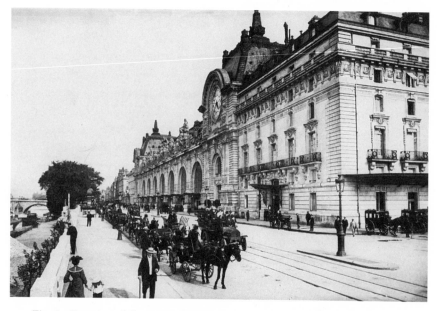

Fig. 1. Exterior of the original Gare d'Orsay after its opening in 1900, from the Quai d'Orsay along the Seine.

built on the site in 1840 to house the Conseil d'État and the Cour de Comptes. The Palais, however, lasted a mere thirty years and was burned down during the Paris Commune in 1871. While other destroyed government buildings such as the Hôtel Salm and the Hôtel de Ville were immediately reconstructed, it took almost another thirty years for a new building to replace the Palais d'Orsay.

In 1897, the Orleans Railway Company received government approval for their plans to build a station on the Orsay site that would extend the train lines from the Gare d'Austerlitz into the center of the city. Architect Victor Laloux, a winner of the Prix de Rome and professor at the École des Beaux-Arts, won the

commission to build the new station and adjoining hotel. The Gare d'Orsay opened in 1900. Unfortunately, technology quickly overtook the convenient placement of the station. Because the tracks could not be lengthened to accommodate the more modern trains, intercity trains were forced to terminate at the Gare d'Austerlitz at the other end of Paris. By 1939, the Gare d'Orsay was used only for small suburban lines.

Although much of the building remained unused, some noteworthy events occurred at the Gare d'Orsay. In 1945, French prisoners of war were welcomed back to France in the main hall. General de Gaulle announced his return to power in the ballroom of the hotel in 1958. In 1962, Orson Welles filmed his version of Kafka's *The Trial* in the station. And from 1974 to 1981, the Renaud-Barrault theater group used the station for its stage.

Meanwhile, the government gathered proposals to permanently replace the station, including designs for an airport, another ministry, and even a school of architecture. The proposal for a grand hotel was finally accepted in the 1960s and the government made plans to raze the station. A building permit for the hotel had already been issued when Jacques Duhamel, the minister of culture under President Georges Pompidou, intervened and prevented the destruction of the Gare d'Orsay in 1971.

At about the same time, the nineteenth-century iron pavilions of Les Halles were being torn down in order to make room for the Plâce Beaubourg and the Pompidou Center. The resulting uproar after the destruction of Les Halles, the site of the central food market in Paris since the twelfth century and called the "belly of Paris" by Émile Zola, forced the government to rethink its plans concerning other historic buildings.[2] In 1973, less than a decade after it had been slated for destruction, the Gare d'Orsay was declared a historical monument. Marc Ambrose-Rendu concluded, in fact, "The Musée d'Orsay represents the

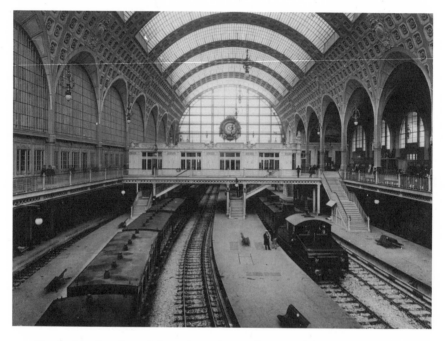

Fig. 2. Interior view of the train station at the turn of the century

apotheosis of recognition of the nineteenth century in Paris and the attempt to save buildings built then."[3]

Saving the Gare d'Orsay

One of the main reasons the French government decided to save the Gare d'Orsay was that it feared a modern building placed at the site would not fit in with its surroundings. The Gare d'Orsay was located on the Seine overlooking the Tuileries and the Louvre in an *arrondissement* (quarter) filled with ministries and monuments. Most government ministries, several embassies, hundreds

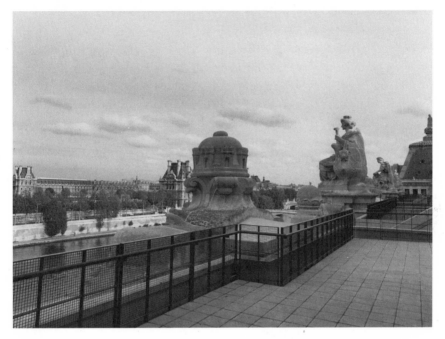

Fig. 3. Three statues, representing the cities of Bordeaux, Toulon, and Nantes, overlooking the Seine and the Louvre, from the third-floor terrace.

of government agencies, the stately Rodin Museum, and Napoleon's Tomb at Les Invalides are all located in the seventh arrondissement.

When building the original station in 1900, Victor Laloux had faced similar constraints in considering an appropriate appearance. In order to conform to the lavish style of the buildings surrounding the Gare d'Orsay, Laloux used the same sized stone for all the facades and foundations of the building in order to create a symmetric and smooth base. He hid the industrial aspects of the station behind an ornate and decorative facade that included three monumental statues representing the train destinations of Bordeaux, Toulon, and Nantes.

Sixty years later, the French government was also concerned with popular reaction to any building plan. As one curator stated, "The best argument for the use of the Gare d'Orsay was that this would prevent an even uglier building from replacing it."[4] Furthermore, the government had been severely criticized for the building of the skyscraper Tour Montparnasse in the late 1960s near the center of the city.[5] (Since that time, skyscrapers such as La Defense have only been built outside the city center).

Just as its architecture had to conform to its surroundings, the use of this building also had to be appropriate. Plans for a hotel or an architecture school were not quite grand enough to correspond to the typical Parisian's view of what was acceptable for the center of Paris. This building had to be a monument, ministry, or museum. Even the last limitation had to be quali-fied; only a museum of high art would be suitable. Although a museum of transportation would have been logical, perhaps, the subject matter was not sufficiently refined for its consecration as a museum in the heart of Paris. The Museum of Technology, for example, is in the suburbs of Paris.

The Need for a New Museum

At the same time that the French government was deciding how to employ the empty station it had just saved, the administration of the Musées de France confronted the issue of overcrowding. The Musée du Jeu de Paume, which housed a world-famous Im-pressionist collection, had the highest number of visitors per square meter of any museum in the world, with an annual average of three-quarters of a million visitors.[6] Due to lack of exhibition space, many of the Louvre's nineteenth-century paintings were

either on loan to other museums or kept in storage. Furthermore, with the opening of the Museum of Modern Art at the Pompidou Center in 1977, many curators perceived a gap, both in time and in artistic styles, between the collections of the Louvre and the Pompidou.

To deal with these issues, Michel Laclotte proposed the creation of a new museum. This museum would house both the Impressionist collection and the academic art of the nineteenth century, in which there had been an increasing interest among professional art historians. Reportedly, the idea to use the Gare d'Orsay as a museum came to Laclotte as he walked with a colleague across the bridge between the Louvre and the Left Bank, where the Gare d'Orsay was situated. At the time, the latest proposal for the station was to use it as the Maison des Provinces Françaises, a center for displaying produce from all over France. Upon approaching a minister concerned with the future of the Gare d'Orsay, Laclotte said, "Sir, we have to choose once and for all where the future of the Gare d'Orsay will lie. Is it to be with Cézanne, or is it to be with Camembert?"[7] Cézanne was ultimately chosen and the proposal for a museum went forth.

The goals of this new museum, as explained to the French National Assembly, were: (1) to provide the proper presentation of the Impressionists; (2) to provide an overall understanding of the art from the period of the post-Romantics, with which the collections in the Louvre ended, to Fauvism, where the Pompidou Center collection began; and (3) to allow the reorganization of the museums of Paris so that Louvre reserves would be shown, space in the Palais de Tokyo would be freed, and the Jeu de Paume could be converted to show temporary exhibitions for which its size was best suited.[8]

A Project of Prestige

For additional reasons, the government decided against private use of the site in favor of creating a new museum. The completion of the second monumental museum in Paris in a decade would bring glory and prestige to the president of France and his government. The French have a strong tradition of both state intervention in the cultural life of the people and state-supported architecture. Commentators have explained the French phenomenon in different ways. Nancy Marmer wrote,

> The underlying assumption of Louis XIV—that one function of and justification for the state patronized art is to enhance a monarch's (or president's) power and indeed to participate in and to enlarge that power—persists today. From Versailles to the Arc du Carrousel to the Centre Pompidou to the Musée d'Orsay, the giant construction of each succeeding government are expressions of that belief.[9]

François Chaslin wrote in his book on François Mitterrand that,

> in Paris, architecture and politics have gone hand-in-hand for the last 15 years or so. Each head of state, or monarch as we might call them, wants to make his mark in stone, to build palaces, and museums that will one day bear his name, and, if at all possible, to preclude the completion of what his predecessor dreamed of building.[10]

Building a monument provides a diversion from economic or political problems in any country. While worldwide press coverage of a new museum might demonstrate the importance of French culture, the French could overlook certain faults in their

government. Moreover, a museum of the nineteenth century would highlight a period when France was clearly culturally dominant, when Paris was the center of the avant-garde in the arts and politics. A monument to that time was a good antidote to the fact that Paris was no longer the universally acclaimed center of culture. Restoring the station also would provide an example of the reappropriation of older French buildings for new uses. Finally, by building two museums in ten years (the Pompidou Center opened in 1977 and the Musée d'Orsay in 1986), as well as increasing spending on other cultural projects, the government was making a bid to change this loss of supremacy and reestablish Paris as the global cultural center.

Throughout its construction, the Orsay was more strongly attached to the president in power than to his political party. In this regard, cultural expression of political leadership in France goes back to at least Louis XIV. Dominique Jamet, who Mitterrand later appointed as the head of the Bibliothèque Nationale project, wrote, "These grand works mark the continuity of government. One does not ask today if Notre Dame, Versailles, the Vendome, or the Bastille were of the right or of the left."[11] Of course, one does not ask because these buildings were created by monarchs, and monarchy is considered on the right of the political spectrum. Jamet's point, however, is that political affiliations become unimportant over time. Instead, these are French projects that reflect French power and culture.

Launch of the Museum

Georges Pompidou was the president who initially approved the preservation of the Orsay in 1973. However, it was Valéry Giscard d'Estaing who launched the project in 1978 with a feasibility

study and the creation of the Établissement Public of the Musée d'Orsay to oversee the development and construction of the museum.[12] The French Senate approved the budget allocations for the construction of the museum, and the station and hotel were reconfirmed as historical monuments. Jacques Rigaud and Jean Jenger were named president and director of the Établissement, respectively.

The museum was first attacked by the press as a project of the right. Pierre Cabanne wrote in 1978 that it was hard to find anything more horrible than the Musée d'Orsay, the "enfant chéri de M. Giscard d'Estaing."[13] After Socialist François Mitterrand was elected president in 1981, however, the museum was linked with the left and Mitterrand's grand projects for Paris. His long list of projects included the creation of the Opera at the Bastille, the urbanization for La Defense, the Grand Louvre pyramid, the Museum of Technology at La Villette, the Arab Institute, and the Bibliothèque Nationale. These presidential works were attacked as excessive both by many journalists and by Mitterrand's political opponents as an attempt to change the face of Paris. Conservative politician Raymond Barre, who regularly battled with Mitterrand in the 1980s, accused Mitterrand of suffering from a Louis XIV complex.[14]

Once the structure was preserved and plans for the museum were approved, the decision-making function passed from the president and the government to the Établissement Public and the curators of the proposed museum. How would the curators' interests differ from those of the president of France? What decisions were made for the interior of the building and how were they made? How was this new architecture to be explained both politically and aesthetically?

Restoration of the Gare d'Orsay

The primary task of the Établissement Public was to manage both the restoration of the Gare d'Orsay and the transformation of the building into a museum. Today the museum has a postmodern interior with plain stone rooms and a monumental passageway in the center of the train shed.[15] This interior differs sharply with the exterior design and what glimpses remain of the original station inside. The contrast between the two styles of architecture is particularly noteworthy considering that, although the government had decided to save the original building, the resulting interior hides most of the original design. The battle over the interior design was one of the major controversies of the Orsay.

The Original Competition

Initially, it seemed as though the plans for the rehabilitation of the nineteenth-century building were being carried out by the Établissement Public. The Établissement held a closed competition in 1979 for the commission of the restoration, with six architects competing: Hervé Baptiste, Yves Boiret, and Jean-Claude Rochette, who had each served as chief architect for the Monuments Historiques; Serge Macel and Pierre Sirvin, who were chief architects for the Batiments Civils et Palais Nationaux; and Pierre Colboc of ACT Architecture, who had no previous connection to the government. The Établissement gave each architect a limited amount of time and money to come up with a design that would transform the station into a museum. The architects' challenge was

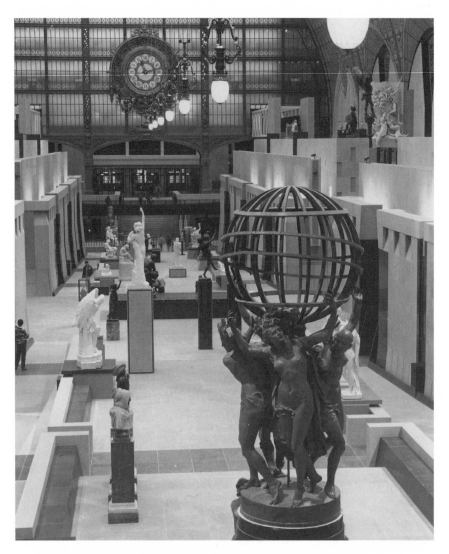

Fig. 4. Main hall of the museum. The clock, frosted glass, chandeliers, and arches are from the original train station; compare with Figure 2.

to create a museum in the huge open space of the train shed that would not overwhelm the works of art or the visitor.

The final plans differed from each other primarily in how much of the original space of the station they preserved and whether the museum's entrance was to be from the quay side on the Seine, as was the station, or from the Rue Bellechasse, the side street. Several of the architects closed off part of the train station to create new levels and had floors jutting out into the main train shed.

Giscard d'Estaing himself made the final decision and chose Pierre Colboc as the architect.[16] Colboc's winning plan was developed as part of a team effort undertaken with his colleagues at ACT Architecture, Renaud Bardon and Jean-Paul Philippon. ACT's plan had best balanced the need to provide display areas for the art while retaining respect for the original building. The museum would open from the Rue Bellechasse. The main train shed would house a winter garden and the museum would be formed by smaller spaces on either side of the shed, the hotel, and the original booking hall, which faced the quay. The entire design was similar to a shopping mall with an open courtyard in the center. The use of the upper areas in the booking hall would also allow for significant natural lighting. ACT designed footbridges to link the two levels with an amphitheater at the far end of the train shed.

And with the choice of ACT, the battle over architecture began. Louis Miquel, a member of the original Scrutiny Committee for the architectural competition, wanted to rethink the government's decision to save the Gare d'Orsay: "My regret is that none of the competing teams had the courage to put itself out of the running by proposing the demolition of the existing building and its replacement by a new one."[17] Other members of the Scrutiny Committee favored Yves Boiret's plan because it kept the original volume of the station, but still others preferred the flexibility of

Figs. 5 and 6. ACT's plans for the main hall show the footbridges and winter garden concept.

ACT's plan regarding the collections.[18] Representing ACT, Colboc noted, "We won because our plan was the best. The other architects did not create a museum."[19]

The conflict between the renovation of the station and the creation of a museum began to emerge, even at these beginning stages. Certain designs better preserved the train station, yet the curators chose the design that best provided for a museum. While it was important to the government to save the building, the curators insisted that the needs of the museum dominate the design. The salvation of the Gare d'Orsay was clearly not as important to them as the creation of the Musée d'Orsay.

ACT's Winning Plan

ACT's plan restored much of the original station. The assimilation of the train shed, the creation of exhibition spaces in the hotel, and the use of natural lighting and various other spaces in the museum sequence preserved the continuity of old to new. ACT restored all of the decorative elements of the original station, including the gilded decor, the garlands on the chandeliers, and the ornamental crests on the roof. The government wanted to recreate the beautiful facade and grand silhouette of the station on the Seine across from the Tuileries. ACT would restore the station to its former glory, while creating a museum that would be functional and pleasing.

Colboc viewed the task of transforming the building as one of developing a new space within the building. Colboc wanted visitors to begin their museum visit at the quay level and then journey to the full height of the station. This approach, he felt, would impress visitors and allow them to appreciate the length and height of the main hall of the station without overwhelming them. Since

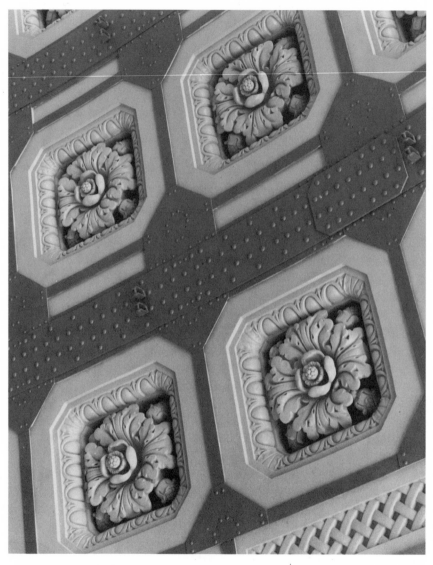

Fig. 7. Detail of restored main hall ceiling decorations.

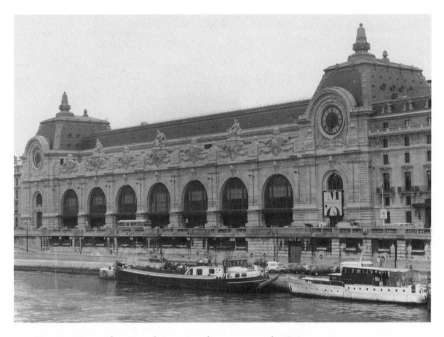

Fig. 8. View of restored exterior, from across the Seine.

the original train station had waiting areas for travelers, it was easy to recreate these spaces as reception areas in the museum. The station restaurant became a bookstore and the hotel dining room was restored to serve as the museum restaurant. On the top floor, a cafe was designed to overlook the Seine. The entrance pavilion on the Rue Bellechasse replaced the previous exit area from the station. Through these changes, the majesty of the building was maintained but made manageable for visitors.

ACT's goal was to preserve the layout of the building, while reducing its scale to obtain a logical succession of diversified spaces for the museum's use. To prevent the vast space of the interior from overpowering the art, ACT designed a series of rooms on

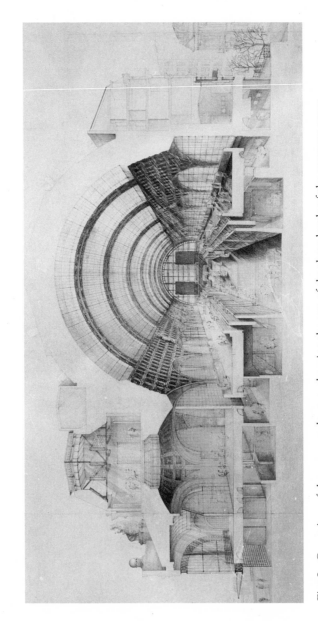

Fig. 9. Crossview of the museum layout, showing the use of the three levels of the museum space.

either side of the train shed, while keeping the main center hall intact. Additional rooms extended into the original booking hall area on the quay side and into the hotel area on the Rue de Lille, the street on the south side of the museum. Exhibition spaces were located on either side of the nave on the ground floor, on the intermediate level in a concourse that overlooked the main hall, and on the upper level of the booking hall where the Impressionists would be shown.

This plan granted the Impressionists the most natural light possible as well as the highest point in the museum. All of the art works would be in small rooms, "organized so one could see the works like small museums in a big museum," according to ACT partner Jean-Paul Philippon.[20] Under this plan, visitors could move throughout the museum without congestion. Indeed, art critic Michael Gibson noted, "The flow from room to room and from one art monument to another is effortless."[21]

The curators accepted many of ACT's major conceptions for the museum, such as the shifted axis of the building, the use of smaller spaces around the train shed, and the flow of the crowd from the first floor. These concepts remain in place today. In addition, all parties agreed that ACT would perform the actual restoration of the structure of the building and the facade. The architectural battle, however, was over the interior design of the museum.

The Battle Over Interior Design

The curators did not like ACT's proposed interior decoration.[22] They did not appreciate the idea of a winter garden, which they described as *pastiche* and *retro*, and they thought the footbridges were too ornate and complicated. More important, the curators

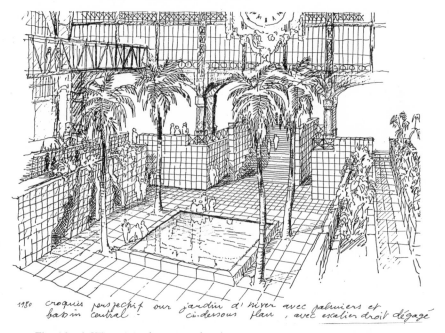

1980 croquis perspectif pour jardin d'hiver avec palmiers et bassin central : ci-dessous plan, avec escalier droit dégagé

Fig. 10. ACT's original concept for the museum entrance included a reflecting pool and trees.

wanted their own architect to oversee the design so that each room would be decorated around the works of art it was supposed to display. Although ACT tried to convince the Établissement Public and the curators that they could manage the entire restoration, they were unsuccessful. In 1980, only one year after the first competition, the Établissement held a second architectural competition, one intended to complement the results of the first. This second competition was won by Italian architect Gae Aulenti.

The stated goal of the second competition was to provide a design complementary to ACT's original plans for the building. The presence of a second architect was originally intended to provoke a dialogue between the ACT and the new architect with-

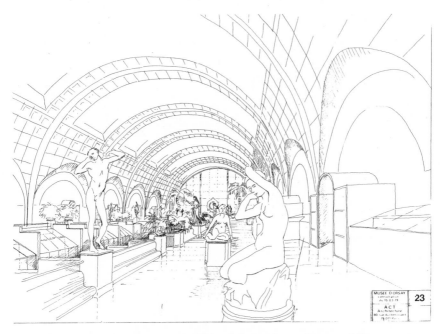

Fig. 11. ACT's Concourse or mid-level design for sculpture exhibit.

out impairing the unity of the interior architecture. The new interior design was to create a visible, yet not contradictory, relationship between the old and new architecture. This original goal of the government, however, was not achieved. Aulenti's interior design comprehensively changed ACT's original plans.

The Process of Change

Gae Aulenti was successful in imposing her changes in the ACT design for a number of reasons. First, she adamantly defended her changes. Although the government had hired Aulenti only to

integrate the details of ACT's layout with the curators' arrangement of the museum through interior design, immediately upon her arrival in Paris in 1980 she challenged many features of ACT's architectural plan. Aulenti urged the elimination of the winter garden, the footbridges, the large staircase at the entrance, and the amphitheater and archway at the far end of the nave. As Établissement Public vice-president Jean Jenger noted, "Aulenti was hired for the furniture, the lighting, the colors, etc., but when she arrived, she said this is not good, this is not good, and so on."[23] Aulenti threatened that if these architectural plans were not changed, she would quit.[24]

Second, Aulenti used the process of decision making to her advantage. She approached the Établissement directly with her changes, rather than discussing them first with ACT, and forced the Établissement to arbitrate between her and the other architects. Critic Michael Vernes stated that Aulenti worked on a virtual counterproject, purposely ignoring ACT's laureate project.[25] Aulenti's insistence on change resulted in continuous debate for two years while ACT, Aulenti, and the Établissement Public worked out the designs in consultation with the curators. This long discussion forced the government, through the Établissement, to play a larger role than it had expected in the planning of the museum.

ACT architect Pierre Colboc referred to the Établissement's arbitration between the architects as a Machiavellian game because the Établissement played the architects against one another.[26] Vice-president Jenger admits that the Établissement went beyond its expected role through its centralized technical management, but justified this action by arguing, "Even if the client is no longer the king, the role [of the client] remains; it is important and fundamental, for no talented architect can achieve good architecture without an authoritative client."[27]

Jenger characterized the debate between ACT and Aulenti as "awkward but fertile exchanges in which they [ACT] accepted changes, some of which they claimed flew in the face of the original coherence of their approach, while more often than not, this proved not to be the case."[28] Colboc, as expected, had a different viewpoint. He cited the towers at the end of the nave as an example of typical Aulenti maneuvering. Aulenti had proposed the towers, Colboc argued, as an initial strategic move in order to gain the ability to change the rest of the interior design. Colboc argued that the towers were decorative and useless, while Aulenti

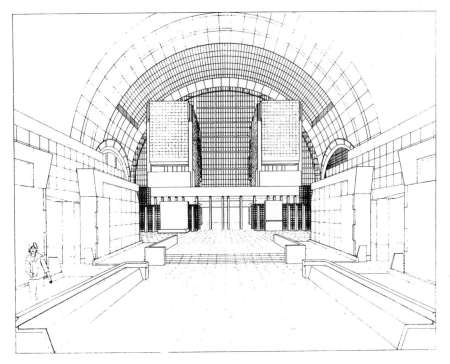

Fig. 12. Revised ACT design replacing the amphitheater with towers at the end of the nave.

argued that they would provide additional exhibition space and were tributes to architecture and urbanism. Her ability to convince the Établissement to adapt her plan demonstrated her influence and strength.[29]

Third, Aulenti prevailed with her plans due to ACT's lack of experience and sophistication with regard to their own plans. Colboc explained that since ACT had spent most of its time on the overall concept of the museum, the details of the interior design clearly needed work when Aulenti arrived. ACT had not yet worked out their major design logic when Aulenti arrived, and their designs remained too complicated. Colboc stated that ACT had already noticed many of the problems Aulenti pointed out, and was moving slowly to resolve them. Aulenti pushed the pace of this resolution faster than ACT could adequately respond. Furthermore, Colboc noted, criticizing a completed plan is much easier than arriving at one in the first place. Colboc admitted that ACT was naive during this battle and did not know how to fight back. Aulenti was older and had more experience dealing with bureaucracy. In reference to working with the French construction crews, Aulenti commented, "As a woman and a foreigner, my ploy was to have them think of me as their mother, whom they must please. That is how I got my way."[30]

ACT's youth and inexperience was also reflected in the Établissement's decision in 1982 to transfer the technical responsibility for the museum to the Parisian firm SET-Foulquier. Because ACT had spent so much time on their designs for the restoration of the museum, sufficient thought had not been given to technical details such as lighting and climate. In fact, one of the reasons for the delay in the museum opening was that neither the architects nor the government had realized that the rumbling of the Metro and RER trains underneath the museum would create vibrations in the collections. This problem required several studies and delays before it could be solved.[31]

Conceptions of the Space

ACT and Gae Aulenti clashed because of their different conceptions of the station and the space in which they were working. ACT began their project with a station that needed to be converted into a museum. One of the preconditions for winning the competition was maintaining respect for the historical monument while creating a museum. ACT spoke of an aesthetic unity created by the old and new architecture when designing their original plans. While Colboc criticized Victor Laloux's design as overly ornate, he respected the axial balance of the Laloux's station plan. Aulenti, on the other hand, began her work in a space already redefined by ACT with a new axis and sequence of rooms. She had no attachment to the established style of the station and saw no reason to keep it intact. The following quote is typical of several interviews in which she discussed the Musée d'Orsay:

> I viewed the station as a place, a terrain where I could put a new architecture in place. The station was, of course, a historic monument, but it does not deserve all the respect given it when it is said that it is a perfect, original, and coherent expression of a past that we must revere. Orsay is basically a box.[32]

Aulenti did not particularly like the Beaux-Art style of the station. Giscard d'Estaing, when asked in an interview if it were possible that Aulenti's interior architecture may have been a deliberate attempt to hide the original building, replied, "I am not sure that Gae likes this architecture. It is French and very characteristic of the nineteenth century. I agree [it may have been deliberate]."[33] Clearly, neither Aulenti nor the curators minded if the postmodern design overshadowed the original ornate architecture. Aulenti's plans actually reflected the postmodern

architecture of a type preferred by the curators. ACT's plans, on the other hand, were more reminiscent of an older style of architecture that the curators rejected.

The battle between Aulenti and ACT was somewhat unique in its power struggles and political outcomes. Jenger wrote that the Établissement Public originally wanted to avoid the use of a second architect, but could not, given the obvious difficulties with ACT.[34] Museum director Michel Laclotte also regretted the tradition of separating the interior design from the station restoration.[35] Laclotte and Jenger agreed, however, that the potential trouble of having an additional architect was outweighed by their desire to change ACT's architectural plans. Colboc actually called Jenger a complete hypocrite for stating he had no choice in the matter: "It is the typical French phenomenon to believe intellectually one thing but then act the other way."[36] But the Établissement, by Jenger's own admission, underestimated the impact of bringing in such an explosive personality as Gae Aulenti. Hiring her late in the process rather than at the beginning of the plans contributed to the controversy between the two firms.

The most important reason that Gae Aulenti succeeded with her plans was that the curators preferred her interior designs. When the Établissement was forced to choose between ACT and Aulenti, the curators lobbied hard to have Aulenti's plans adopted. From the beginning, the curators had identified closely with her postmodern designs. Shortly after the second competition, Michel Laclotte declared, "We knew her work and felt her ideas were best suited to ours. She understood art as well as architecture."[37] As Françoise Cachin, the director of the Musée d'Orsay, explained, "Gae understood very well what we wanted— a game between the decor and the contents so that in every room there would be a view of the station to provide the perspective of the space."[38]

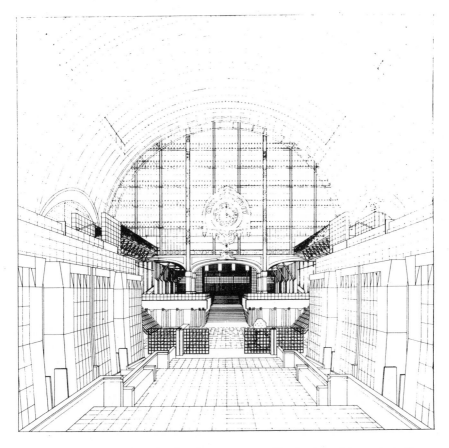

Fig. 13. The new concept for the entrance and beginning of the main hall replaced the winter garden with the more solid Aulenti design.

Aulenti's Interior Design

Aulenti worked closely with the curators to develop the layout for specific parts of the collection. Describing their work together, Laclotte stated, "We built a program determining where each

piece of art should go. We talked our plans through with Gae nearly every day. It was a constant dialogue of ideas about location and presentation."[39] Aulenti viewed her role as "show[ing] off the works to their best advantage."[40] In her eyes, the decor of the Impressionist rooms should be more casual to match the art while the rooms on the second level with salon art should be more formal. An example of how the layout of the art displays and the architecture were planned together is that in each gallery, as in many museums, the most important painting is perfectly framed by the architecture and can be seen from across the museum. Aulenti insisted that each room on either side of the nave be varied according to its display. After the changes were made, she pronounced, "It is not a simple path through the museum. One must think about movement and this generates reflection on the art."[41]

As a the result of the battle between ACT and Aulenti, very little of what the museum visitor now sees is ACT's work. While the grand conception and organization of space were clearly their ideas, the details of color, lighting, and display of works, as well as the overall design of the interior, were Aulenti's. In the end, Aulenti simplified ACT's elaborate style by eliminating the grand staircase, the footbridges, and the winter garden. She changed the main walkway of the museum from a rampway to separate platforms and staircases. And, as indicated earlier, she replaced the grand archway and amphitheater with two towers at the end of the nave.

Aulenti relied on limestone and lighting to provide unity for the diversity of rooms and works of art. Different colored limestone is employed throughout the museum for both the floors and artificial walls. Aulenti tried to approximate natural light in each room by using two principles: (1) control the natural light so that it will blend with the artificial light and (2) always have the artificial light fall indirectly on the art work. Aulenti par-

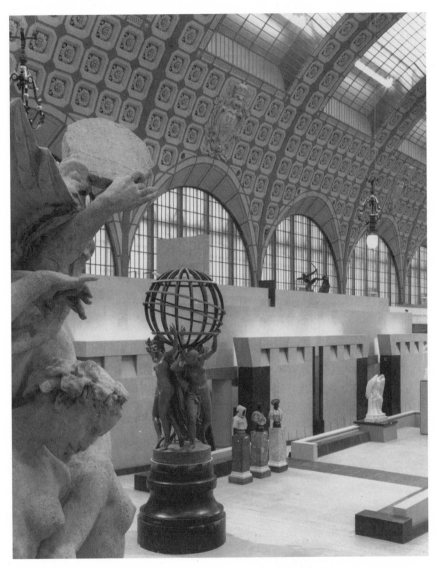

Fig. 14. Restored main hall ceiling contrasts with its limestone interior design.

ticularly believed that lighting was crucial to the museum. "I am convinced, and the work here proves it, that the architecture of a museum depends on how the system of lighting is integrated."[42]

The basic difference between ACT's plans and Aulenti's changes was that ACT's plans complemented the original architecture while the Aulenti's results contrasted with it. The interior design of the Orsay was monumental and powerful as opposed to the ornate, decorative exterior. Today's visitor, therefore, sees a postmodern interior in a nineteenth-century shell.

Postmodern Triumph

The resulting museum was highly controversial and the architect herself contributed to the uproar. During the 1980s, Gae Aulenti had four museum commissions: the Musée d'Orsay, the permanent collection galleries of the Pompidou Center, the Palazzo Grassi in Venice, and National Museum of Catalan Art in Barcelona. Like the Musée d'Orsay, the National Museum in Barcelona was created in a vast and ornate older building, the National Palace. These commissions no doubt inspired jealousy and created controversy.[43]

Aulenti's Goals

Aulenti herself was rather vocal about her own work. She theorized that, "the difference between men and women is that men want power and women want knowledge."[44] Because of this belief, she refused to specialize in any one style of architecture in order to preserve her ability to work in a diverse array of cir-

cumstances. Aulenti's broad range of design commissions include operatic set designs at La Scala, showrooms for Olivetti and Fiat, and a Beverly Hills boutique for Adrienne Vittadini. Aulenti has claimed that her ability to design a wide variety of items was the reason she received so many commissions. "If you know good architecture, you can make a good lamp, but making a good lamp does not mean you can do architecture."[45]

Aulenti rejected the idea that she had a particular style and asserted repeatedly that she was not interested in leaving a signature on her works. To preserve her autonomy, she continually argued against being labeled postmodern. "[I]f there is a style, it is only through the quality of the light and the unity and force of the material."[46] Her own style, Aulenti said, was "purely an intellectual notion; I like the concrete."[47]

In reference to the style used in the museum, Aulenti explained that stronger architecture was necessary to make the museum "a place to pass time and not just to pass through."[48] She also compared the Orsay to an airport where one receives the services without really noticing the architecture. But if Aulenti assumed that the public and press would not notice the architecture, she underestimated the extent of their interest considerably. Every journal and newspaper had its own critique of the architecture and interior design.

Aulenti's goal of providing a strong architecture for the art, one concrete and simple, was clearly supported by the curators and many critics. Geneviève Lacambre, the head curator at the Musée d'Orsay, stated bluntly, "You need monumental architecture for a monumental space."[49] Most of Aulenti's supporters argued that a large station should have very powerful architecture or the visitor would be overwhelmed by the vast space in the main hall. American architect Philip Johnson proclaimed, "Gae represents the 80's, it is a magnificent work."[50] He believed

that postmodern adaptation of the past paved the way for future architectural styles.

Other supporters argued that the monumental style gave permanence to the museum. If the new architecture were not so heavy, the art would appear as if it were just temporarily placed in the station. Aulenti's architecture also created the intimacy of small rooms necessary for museum display. On the defensive, Françoise Cachin argued, "The press never looks beyond the main hall to the rooms that provide calm for the visitor. Nor do they talk about the variety of spaces or the adaptation to a difficult space."[51] Some critics also enjoyed the combination of styles. Vernes wrote, "ACT provided the transversal while Aulenti made the museum vertical and unified."[52] Lorier gave it the highest praise of the any of the French press, noting, "Without a doubt, [this is] one of the rare examples where the furnishings and the building blend."[53]

Criticism of the Design

The majority of the French and architectural press, however, criticized the interior design for a variety of aesthetic reasons. Some critics lamented the loss of the original architecture that was hidden by Aulenti's design. Paul Goldberger, the chief cultural correspondent for *The New York Times*, felt that the architecture was insensitive to the original Gare d'Orsay. In fact, Goldberger wrote, "It does little to advance the art of museum design and sets architectural recycling back a generation."[54] Thomas Matthews, in *Progressive Architecture,* wrote, "Aulenti sacrifices the integrity of the station."[55] "Aulenti ignores the station," claimed art historian Pierre Vaisse, "which she does not appreciate, and concentrates upon affirming her personal man-

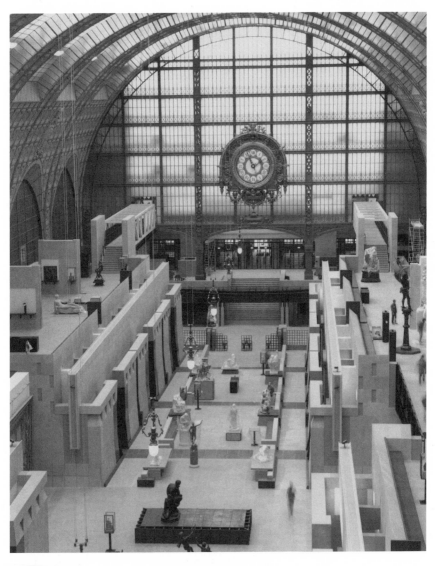

Fig. 15. The main hall and concourses, from above the nave.

nerism."[56] *Le Figaro*'s Veronique Prat declared, "[T]he station is so superb, one cannot forgive Aulenti for brutally opposing Laloux's style."[57] These criticisms are based on the belief that the original architecture was a work of quality, a belief not held by Aulenti or the curators. These reviewers' major critique of Aulenti was not *her* style of architecture, but rather the fact that it did not match Laloux's.

More than one critic saw an analogy between the museum and the Egyptian pyramids due to the beige color and layout of the main hall. Jeanine Warnod's first impressions of the museum were "rigor, ugliness, and coldness."[58] Philip Jodidio called the museum "Aida on the Seine," while Peter Buchanan wrote an article entitled "Tuut-Tuut Tutenkahmen" because of the mix of steam trains and King Tut.[59] Pierre Schneider of *L'Express* wrote that the nave looked like a comic book rendering of the Valley of the Kings.[60] *London Times* critic Charles Gandee pronounced, "The massive nave is a disaster. The meeting of the Nile and the Seine is alien, morbid, and distracting."[61]

Another popular analogy offered was one to the stark architecture of the Third Reich. Françoise Loyer wrote that the architecture was a compromise between Louis Kahn and Albert Speer, while Charles-Henri Monvert, in reference to the two towers, argued, "Frankly, it is neo-Nazi architecture."[62] Art historian Patricia Mainardi agreed with both of these aesthetic analogies, with an added political interpretation. She argued that the architecture was motivated by a desire to give an image of state power.[63]

Critics also asserted that the architecture overwhelmed the art it was supposed to display. Artist Pol Bury entitled his review of the Orsay, which contended that the architecture swallowed the art, "Les Architectes Cannibales" and called Aulenti "Attila le Batisseur."[64] "While seeking to celebrate these sculptures, the installation, in fact, trivializes sculpture," wrote Brenson in *The*

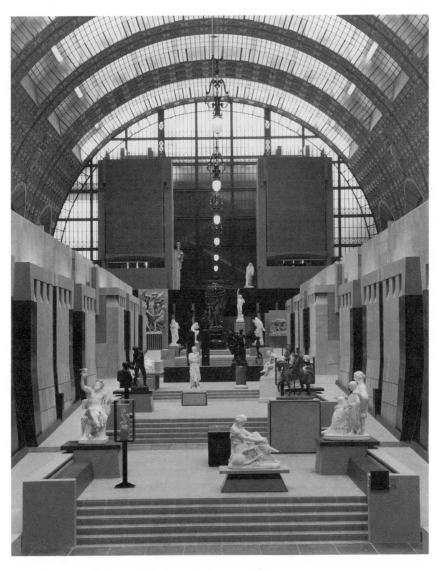

Fig. 16. Main hall, with view of towers.

New York Times.[65] Art historians Charles Rosen and Henri Zerner noted that the stagy decor consistently pulled the eye in different directions, making it difficult to view the art.[66] "[T]he lack of harmony between the forms and the material in the architecture constantly turn the attention away from the art, which should be the most important," argued Pierre Cabanne of *Le Matin.*[67] Matthews wrote that the paintings were like "butterflies pegged to the stone walls, dried and mounted," and Goldberger argued that the art was caught in the middle of a battle between Laloux and Aulenti.[68] "At no point can a group of pictures be seen in a simple clear cut space without an intruding column, a change in level, a break in the wall, or some other interruption," complained Courtauld Institute art professor John House in *Burlington Magazine.* "It is a deliberate strategy to emphasize the artifice of display."[69] Gilbert Lascault in *Quinzaine Litteraire* summarized, "[T]he indiscreet omnipresence of Aulenti's architecture seems as though she wanted to proved that she had read a dictionary of architecture and that she could illustrate most of its articles."[70] Even director Michel Laclotte admitted that the stone background of the exhibition space complements certain works more than others.[71]

Some commentators believed that the interior design complemented the salon art more than the Impressionist art. Since salon paintings are normally much larger in scale than Realist and Impressionist art, Henri Zerner argued, they would stand out against more complicated architecture, while the smaller paintings would be lost amid the details.[72] Stephen Bann believed that the heavy stone architecture subtracted from the Impressionist paintings, while giving solidity to the flighty academics.[73]

The variety of accusations about Aulenti's architecture reflected the biases of her critics and demonstrated a wide range of

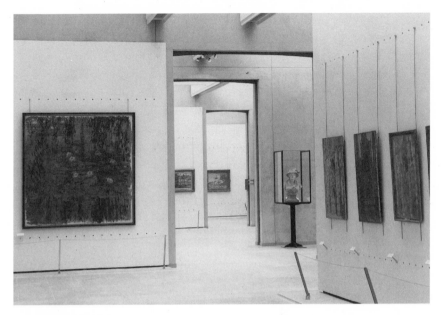

Fig. 17. View through a series of third-floor rooms with Impressionist paintings.

tastes and cultural attitudes. Moreover, one must realize when reading the harsh criticism of the museum that this criticism was somewhat expected as part of French life. Carol Vogel explained, "As a culture, the French are opposed to change. They are not very progressive in their thinking about architecture so that when new buildings are designed, they are usually opposed to them."[74] "The French are not only difficult to please, but like to be seen being displeased," concurred Richard Bernstein.[75] Referring to the debate over the Musée d'Orsay, *Los Angeles Times* art critic William Wilson noted that "sometimes you can't tell whether the French really hate progress or if they just love to argue."[76]

The criticism leveled at the museum design was directed at the architect, and not at the curators who supported her work and helped plan the interior of the museum. Gae Aulenti served as a shield for Michel Laclotte and Françoise Cachin. While the curators expressed their approval of the museum interior and explained how closely they worked with Aulenti, none of the reviews assailed their power to choose such a controversial interior. Although Giscard d'Estaing approved the more elaborate ACT interior, the resultant interior design demonstrated the power of the curators. The curators managed to change the architect when they did not approve of the original plans and then avoid criticism for the result. In the next set of decisions, where the curators were solely responsible for the selection of the collection, they were not as successful in avoiding criticism.

CHAPTER TWO

—=→●←=—

The Collection

It's all up on the walls of the Orsay—the good, the bad,
and the atrocious. —Jed Perl, 1987

So are some of the most urgent questions that can be
raised about the presentation and interpretation of art.
 —Michael Brenson, 1988

Chronological Range of the Installations

The Musée d'Orsay was originally named the Museum of the
Nineteenth Century in the documents of the laws and budget
allocation passed by the National Assembly in 1981.[1] The de-
scriptions of the collections to be displayed, however, indicated
that only the second half of the nineteenth century would be
represented. An agreement on a more definitive chronological

range of works to be displayed was necessary before the installations could be fully assembled.

The fact that the museum was to be multidisciplinary exacerbated the difficulty of this determination. While collections of paintings and sculpture are normally organized by date and school, museums of photography and decorative arts usually cover the entire medium rather than a chosen period. The French government needed dates that would correspond to the desired linkage in painting and sculpture between the Louvre and the Pompidou Center, dates that would make sense for the collections other than painting and sculpture, and dates that the public and art critics would understand as logical and important.

Starting Date of the Collections

When Giscard d'Estaing approved the plans for the museum, he requested that the museum's installation begin with Romantic works from 1830, including Delacroix's *Liberty Leading the People*.[2] Giscard preferred the more classic artists Delacroix and Ingres to the later Realists and Impressionists and wanted the museum to highlight his favorite artists. Although the Romantic movement began around 1805, 1830 is considered the pinnacle year of Romantic art and literature. It was also the beginning of the constitutional monarchy under Louis-Philippe.[3] Commencing the collection in 1830 would send a political message to the public, regardless of Giscard's actual aesthetic preferences. Giscard had already been identified as a conservative president and his choice of 1830 gave rise to even more accusations of an imperial presidency.[4]

Françoise Cachin, however, wanted the museum's installation to begin in 1863, the year of the first Salon des Refusés. Through-

out most of the nineteenth century, showing work in the official Salon was both the highest honor a painter could receive and virtually the only way the artist could display his art to the public. The French Academy of Painting and Sculpture, which organized the annual salons, was the arbiter of good taste from the time of its creation by Louis XIV in 1648 to the end of the nineteenth century. The Academy gave study grants, awarded prizes, commissioned works of art, and generally determined who succeeded and who did not. Despite their revolutionary artistic styles, even Impressionists Renoir and Degas measured their success by whether or not they were shown in the Salon.[5]

The creation of the Salon des Refusés is considered a turning point in French art history because it was the first large exhibition of Impressionist art. The Salon des Refusés was mounted as an alternative salon after the Impressionist paintings were rejected by the official Salon. By its very existence, the Salon des Refusés signaled the demise of the Salon. The curators of the Musée d'Orsay, who believed that the date of the first show in 1863 outside the Salon marked the beginning of modern art, wanted to begin the collection with this well-known date in art history. Thus, Manet's *Déjeuner sur L'Herbe*, first exhibited in 1863 at the Salon des Refusés, could be the central starting point for the appreciation of French modern art.

Because of the conflict between the wishes of the government and the wishes of the curators, the earliest date to be represented in the museum's collection was seriously debated. As late as 1981, the outcome of this debate remained unclear. As curator Michel Laclotte explained, "Giscard inconvenienced us, but he made us study the fundamental ideas of our program."[6]

The date 1830 was not feasible for several reasons. Laclotte and other curators argued that, in order to understand Ingres and Delacroix properly, the collection would have to begin in

1805–15—with David, Géricault, and other early Romantics —
in order to keep the classic David-to-Delacroix progression in
early nineteenth-century painting. To do this meant transferring
over six hundred paintings and sculptures from the Louvre and
disrupting some of the Louvre's most famous and well-planned
rooms. Romantic works, unlike other schools of painting to be
shown in the Musée d'Orsay, did not lack space in the Louvre
and were prominently displayed there. In addition, the display
of so many works from the first half of the nineteenth century
would limit the space available for works from the second half.
The Orsay would face the same overcrowding of its collections
as did the Louvre. Finally, with Giscard out of office by the end
of 1981, it was possible to ignore his original request.

Neither was 1863 chosen as the starting date. Since everyone
wanted the Musée d'Orsay to encompass more than painting,
the starting date had to correspond somewhat to the other items
in the collection. Photography began in 1839, cinema did not
begin until 1895, and sculpture had no breaking point as well
known as 1863. In addition, the museum had plans to display
art from other European countries. The date of 1863 was only
significant to French painting.

1848: The Starting Date

The year 1848 was finally chosen as a starting point. First, 1848
was a clear compromise between 1830 and 1863 and could be
explained as coinciding with the originally stated plans for a
museum of the second half of the nineteenth century. Second,
the date made administrative and artistic sense since moving the
date from 1863 to 1848 would allow all of the early Manet and
Degas to be displayed.

More important, 1848 was a significant date in art history: the most famous example of academic work, *Romans of the Decadence* by Thomas Couture, was exhibited in 1848. This large, ornate, historic work was an important precursor of many Salon paintings. The Realist school also gained prominence when Gustave Courbet exhibited his controversial *Burial at Ornans* at the Salon of 1848.

To many art historians, the development of the Realist school marks the beginning of modern art. Geneviève Lacambre, the head curator at the Orsay, argued that starting the museum's collection in 1848 would correct the common misperception that Impressionists were the first modern painters.[7] The Realists' paintings of everyday life and popular subjects on canvases as large as those usually reserved for paintings depicting royalty, mythology, or religious subjects challenged the traditional art hierarchy. They questioned the assumption that only historical paintings could be portrayed on a large scale and established the model upon which the Impressionists would later expand. Furthermore, Laclotte explained, with Millet and Courbet entering the Salon at mid-century, the opening of the Crystal Palace in 1850, a new wing of the Louvre in 1852, and the founding of the Pre-Raphaelite Brotherhood in 1848, the mid-century mark was more or less equally significant to all types of art[8] and would better fit with the Orsay's goal of being more than a museum of painting.

Finally, 1848 was chosen for its political and historical significance. It was a year of social turmoil and revolution across Europe. The French people overthrew their citizen-king and replaced him with the Second Republic. It was the year Marx wrote his *Communist Manifesto*. Beginning the collection in 1848 highlighted the republican form of government rather that the constitutional monarchy that would have been heralded by a starting date of 1830.[9]

Ending Date of the Collections

There was also debate over the ending date of the installations. Since the Museum of Modern Art at the Pompidou Center began with Picasso, the logical ending date for the painting collection in the Musée d'Orsay was around 1905. Yet, once again, that date did not correspond to all of the artistic media to be displayed at Orsay. In addition, Madeleine Rebérioux, the social historian and university professor who was appointed as vice-president of the Établissement Public by François Mitterrand, insisted on a date that everyone could understand. Rebérioux favored ending the Orsay collection in 1914 so that the birth of social movements could be included in the museum. Soon after her appointment in 1981, Rebérioux announced, "My first proposal is that the museum should end in 1914 and not 1905. The grand crises of industrialization occurred in that period; the art from 1905 to 1914 reflects [those crises] and should be shown in the museum."[10] Rebérioux maintained that ending the museum in 1905 would split the most important decade in French social history. In her quest to display and integrate history in the museum, Rebérioux thought it necessary to have prominent dates in history, rather than in art, around which her plan could be molded.

A purely historical and political date marked the official end of the museum's installation: 1914 was finally chosen as the ending date of the collections. The government was able to win this battle with the curators because the curator's choice of 1905, like 1863, was a date applicable only to painting. Furthermore, the extension of the collections to 1914 from 1905, unlike the choices of 1830, 1848, or 1863, would not change the contents of the installation or any other curatorial plans. The ending date of 1914 was also left flexible so that some works by artists such

as Monet and Vuillard would be exhibited at the Orsay, while the Cubist and Fauvist works remained at the Pompidou.

The first floor rooms in the Musée d'Orsay were to display the pre-Impressionist painting collection. The rooms on the right aisle would reflect Giscard's desire to begin the museum with the Romantics. *Chasse de Lions* by Delacroix and *Le Source* by Ingres, as well as other later works by these artists, could also be exhibited in these rooms. The remaining rooms on the right aisle would display the School of Ingres and the development of eclecticism. The left aisle would begin with Daumier and Millet and show the development of Realism and early Impressionism. Françoise Cachin was pleased that, with the inclusion of the Romantics, two different dialectics could be shown: one between Delacroix and Ingres, which is demonstrated in the right aisle, and one between the academics and the avant-garde, which is displayed in the two aisles across from one another in the main nave.

Criticism of the Dates

The most common criticism of the inclusive dates of the collection was that Courbet's paintings were taken out of the Louvre and placed in the Musée d'Orsay. Courbet's most monumental works, *Burial at Ornans* and *L'Atelier*, face each other in a room set back from the nave of the station, where the booking hall used to be. Critics contended that Courbet had been taken out of his historical perspective. Patricia Mainardi asserted, "You lose the dialectic of seeing history work itself out."[11] The size of Courbet's paintings, as well as his writings about his own work, clearly demonstrates that the paintings were executed in the grand tradition of history painting. They were intended for the Salon

and were based on the examples of David, Géricault, and Delacroix. Without the rooms of history painting that preceded Courbet's paintings in the Louvre, some insisted, to display his work at the Orsay made no sense. Rosen and Zerner regarded Courbet as the *end* of a tradition rather than a beginning, and concluded that the curators "should have left Courbet where he was logical."[12]

The issue for most critics was whether Courbet was the last great history painters or the first modern artist. The problem, of course, was that his work had components of each. While Courbet's grand paintings are in the tradition of monumental painting in terms of size and format, their style and the content are clear precursors of Manet and other Realists.

Other critics of the chosen dates charged that the curators marginalized Ingres and Delacroix because what follows their works in sequence in the right aisle is so bad. The right aisle begins with classic late Ingres and Delacroix in the first room. The remaining rooms, however, display more academic art, including Clésinger's notorious sculpture *Woman Stung by a Serpent*, first exhibited at the Salon of 1847.

The significance of selecting the chronological boundaries of the museum's installations cannot be overlooked. By choosing prominent political dates, the curators acknowledged the role of history both in the creation and role of art and as reflecting its social and cultural context. The choice of 1848 highlights the rise of the Second Republic rather than the July Monarchy favored by the conservative Giscard.

The date 1848 also reflects the curators' belief that the Realist school was the forerunner of modern art. The Orsay became the bridge between the traditional French art of the Louvre and the modern French art of the Pompidou. The date showed the

development from the royal patronage system reflected by the Louvre to the supremacy of the modern art market manifested in Beaubourg. As the following section discusses, the curators also believed that the path to Beaubourg was not forged by the Realists and Impressionists in isolation but through their struggle with the Academy.

The Academy Versus the Impressionists

The debate over the art to be displayed in the museum began immediately with the first floor galleries. The contrast in style between the art in the right aisle and the art in the left aisle became very clear and accurately reflected the differences among the many schools of art of the nineteenth century. The right aisle galleries show Ingres and Delacroix with the School of Ingres and include the works of Duval, Chassériau, Puvis de Chavannes, and Cabanel. The progression continues into the Salon painting of the second half of the nineteenth century, which is shown in the main nave and on the second floor.

These salon painters remained faithful to the Academy and the old hierarchies of art while the Realists and Impressionists tried to break down the hierarchies. Many were derisively called *pompiers* because they painted historical landscapes with Roman soldiers who wore helmets like those of firemen (*pompiers* in French). Although the term *pompiers* was initially descriptive, it quickly became derogatory. Most of these artists were known for painting soft, voluptuous nudes and were accused of using the painting of history solely as an excuse for painting

erotica; Gérôme's *Cockfight* was an example. Prominent *pompiers* represented in the Orsay include Gérôme, Cabanel, Couture, and Bouguereau. In fact, Degas used the term "bouguerated" to refer to over-finished surfaces; Van Gogh called Bouguereau a well-paid maker of "soft, pretty things."[13]

In contrast to the right, the galleries of the left aisle of the first floor display the Realists (Daumier, Millet, Courbet, and Pils), the Barbizon school (Corot, Troyon, and Daubigny), the "group of 1863" from the Salon des Refusés (Fantin-Latour, Manet, and Pissarro), and the beginning of Impressionism (Bazille and early Monet). This stylistic progression continues on the third floor where the work of Impressionists and Post-Impressionist painters are displayed.

The sculpture collection also proved to be a lightning rod for debate over museum collection, presumably because such works, the majority of which were in the academic style, are prominently displayed in the main nave. As Anne Pingeot, a curator of sculpture at the Orsay, stated, "One cannot go up to the Impressionists without passing the sculpture collection."[14] The sculpture collection also includes Neoclassic, Romantic, Eclectic, Realist, and Primitive sculpture. Most of the pieces came from the reserves at the Louvre because the Jeu de Paume was too small to display a wider variety of sculpture. The sculptures of Rodin and Degas, well known to the general public, are shown on the second floor. The work of sculptors such as Claudel, Carpeaux, Maillol, and Clésinger had received less exposure historically but are shown prominently on the first floor. Clésinger's fanciful and erotic *Woman Stung by a Serpent*—controversial even in the nineteenth century—and other salon sculpture fueled the debate concerning the positions of the *pompiers* relative to modern sculptors such as Rodin.

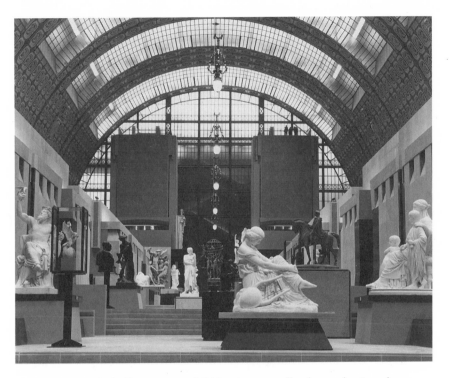

Fig. 18. Main hall entrance, exhibiting in, generally, the academic style and a variety of sculpture.

The Rebirth of Academic Art

Although academic art was highly acclaimed in the nineteenth century, the acceptance of the Impressionists and the popularity of modern art resulted in the complete decline of academic art's popularity. The art market offers a striking index of the changing fortunes of the various schools. A Bouguereau painting in 1872 was sold for 21,600 francs (almost US$14,000); in 1970, a

Bouguereau painting went for half that amount at US$7,000. By comparison, a Cézanne painting in 1895 only cost 2 francs (about 10 cents); in 1973, his *Paysages du Midi* was sold for US$2.4 million.[15]

Academic art inspired reaction from most art critics. Art historians who felt that academic art was not as bad as was once thought praised the Orsay curators for showing the art. They viewed the Orsay as the first opportunity to restore the reputation of this unjustly maligned art school. For example, conservative art historian Pierre Vaisse linked academic art to both the elite and the state. Vaisse was pleased to have the art shown and approved of both its political message and its aesthetics.[16] From the other end of the political spectrum, yet with similar aesthetic tastes, critic Albert Boime wrote, "The popularity of the museum vindicates the attempts to rehabilitate the academy."[17]

Some critics viewed the Musée d'Orsay as a vehicle for reconciliation between the academics and the avant-garde, between the conservatives and the liberals. Giscard argued that the harsh distinction between the two types of art should be smoothed over. "The grand civilizations have always made a synthesis between tradition and modernity, there is . . . no rupture."[18] Henri Mercillon, a member of the Conseil Artistique de la Reunion des Musées Nationaux, expounded, "It might be that in the Orsay, it has become possible at long last to reconcile the various currents of 19th century painting."[19]

A majority of critics, however, castigated the Orsay for its apparent lack of taste by showing the academic art at all. Artist Bernard Buffet complained, "Mixing the *pompiers* and the Impressionists is like mixing up dish towels with napkins."[20] Art critic O'Sullivan asked, "When is kitsch no longer kitsch? When

it is put on display at the Musée d'Orsay, the world's greatest museum of 19th century art."[21] Jed Perl wrote in *The New Republic*:

> Because the curators were unwilling to make aesthetic judgments, the museum ultimately fails to express the real exhilaration of living in a culture in that time, which has to do with separating the good from the bad. It is impossible to be true simultaneously to the academics who thought Manet did not fulfill his promise and those who saw Manet as the most daring painter of the day. While these people lived at the same time, they were mentally worlds apart.[22]

In Perl's mind, the museum did not provide historical accuracy but historical confusion. He argued that the mixing together of these types of art in a single museum indicated that the "very idea of taste" was "falling apart."[23]

The Orsay's exhibition of academic art also encountered criticism based on political interpretations of the art. *The Manchester Guardian Weekly* scolded, "Orsay rewrites history and undermines the ideological stance of the most famous exhibitions [the Impressionists] by blithely hanging friend with foe."[24] Rosen and Zerner assailed the neoconservatives' success in exhibiting the academics.[25] Mainardi worried that the spectacle in the Orsay had "a reading of history that reinforces the authority of the state, even in aesthetics."[26] Mainardi's fear was that, by restoring the *pompiers*, the museum would demonstrate that the taste of the state prevailed. In addition, the very ability of the French government to create a museum, control its architectural design, and shape its collection reinforced its concern of the triumph of authoritarian state power.

On the other hand, some critics did not believe that the museum was rehabilitating the Academy at all. In fact, they asserted, the academics were hurt by comparison with the avant-garde. Nicole Duault of *France-Soir* lamented, "The *pompiers* do not have a chance. They risk being forgotten again."[27] To the question of whether the people of France would change their taste in art, Jeanine Warnod responded, "Isn't it already decided?"[28] Warnod pointed out that the lines of former patrons of the Jeu de Paume proceeded quickly to the Galerie des Hauteurs, where the Impressionists were displayed, skipping the collections of academic art. And, in fact, Paul Lewis of *The New York Times* urged patrons to do just that: "Don't waste time downstairs in the impressive main hall. The Orsay museum's finest treasures, the collection of Impressionist paintings by Monet, Van Gogh, Renoir, Pissarro, and others are all crowded into the last four rooms upstairs."[29]

Correcting Past Condemnation

Despite the inevitable criticism of their decisions, the curators felt strongly about the importance of exhibiting academic art. First, they wanted to avoid mimicking the faults of the state one hundred years earlier in making harsh, unfair judgments against the Impressionists. Second, the curators maintained that it was difficult to characterize the *pompiers* and make a clear division between the good and bad art. Finally, the curators regarded both types of art as accurately reflecting the second half of the nineteenth century. They wanted their museum to be historically complete and considered it important to show the differences between the Academy and the avant-garde rather than hang the avant-garde in isolation.

The curators felt that a parallel could be made between the state's unfair judgment of the Impressionists in the late nineteenth century and the art world's judgment of the *pompiers* at the beginning of the twentieth century. One reason why so many Americans and other foreigners enjoy Impressionist art is because the French government refused to buy this art during the nineteenth century;[30] therefore, Impressionist dealers were forced to export the art, prices remained low, and collectors around the world acquired it. Famous collections of Impressionist art can be found in numerous American and international cities such as New York, Chicago, Washington D.C., and St. Petersburg. Although academic art fell from favor in the beginning of the twentieth century, it was not until the opening of the Jeu de Paume in 1947 that the French government officially sanctioned avant-garde art.

The difference in treatment can also be seen in the origin of the museum's collection. Most paintings in the Louvre are from royal collections or acquisitions. Much of the Impressionist art in the Orsay was donated by private collectors. The private collector, not the state, was the original patron of the Musée d'Orsay.

The changing relationship between the government and the artists during their lifetimes demonstrates the capriciousness of government censure. At the beginning of his career, Delacroix was branded by art critics as a radical, someone whose paintings were bought by the state only to be hidden away safely. By the end of his career, he was an acclaimed painter. The government "discovered" the beauty of Delacroix's work when faced with the even more revolutionary Realists. As an anonymous commentator in the *Revue Universelle des Arts* in 1855 queried, "If in 1835 M. Eugène Delacroix, the terror of the Academy, did not even receive an honorable mention, who can assure me that

Courbet will not be a medal winner in 1865? Alas! In art as in politics, isn't the error of today almost always the truth of tomorrow?"[31] And, in fact, Courbet himself was hailed by the Academy as Impressionism began entering the Salon.

If the state could condemn past art that was later hailed as extraordinary, who is to say that what artists the state now disparages—the academics—would not find favor in the future? As art critic Robert Hughes wrote, "Who in 1890, would have predicted the obscure and clumsy Cézanne would cause a revolution in values that would oust the mastery, 'impeccable' diction of Bouguereau from the history books? (But then, who in 1960 would have bet on Bouguereau's return to our museums in the eclectic revivalism of the 1980's?)."[32] While the curators did not necessarily hold the academic style in high esteem, they did not want to condemn it to the point of excluding an entire school. Laclotte explained that the Orsay had "a more equal and less maniacal vision of the 19th century" than other French museums.[33]

Reconciliation of Nineteenth-Century Art

The Orsay brought the art of the nineteenth century together, both in an act of reconciliation and as an implicit criticism of state-sponsored condemnation. Mercillon articulated, "Orsay constitutes an act of atonement for past errors and an act of faith in the future. It constitutes an appeal against judgment." He cited curator Philippe Durey, who concurred, "Any rehabilitation leaves a bitter taste; bitterness for the works too hastily condemned and the consequences, bitterness for the time lost and the prejudice suffered."[34]

Characterization of the *pompiers* was also difficult. First, the critics and the curators each defined *pompiers* differently.

Françoise Cachin claimed that true *pompier* art is actually not included in the museum. "Chocarne-Moreau with the *petits pâtissiers* or Chabas and his nude sea nymphs are not in the museum. The very bad painting remains very bad."[35] Laclotte concurred, "There are not really that many *pompiers*. We show more independents."[36]

One justification used for separating academic art from Impressionist art was that the two artistic styles had no relation to one another. Yet, categorizing academic art with the avant-garde is more complex in light of the actual history of the period. For example, both Manet and Degas were trained in *ateliers* (apprentice workshops), the traditional route for an artist. In 1880, Bazille wrote to his family that the Impressionists still hoped to change the Salon judges' opinions so they would not be forced to exhibit on their own.[37] The Impressionists finally held their first independent show in 1874, but not until the late 1880s did they completely disregard the Salon as the official arbiters of taste.

Second, since many Impressionists did not necessarily desire to be revolutionary, any separation between their art and state-sponsored art was not as apparent as some historians would have preferred. While Rosen and Zerner were famous for arguing that there was a clear rupture between the Academy and the Impressionists, Boime was equally famous for maintaining that it was impossible to detach the Impressionists from the Academy. "Even Van Gogh liked Bouguereau," he noted.[38]

Third, the distinction between academic art and Impressionism becomes even more blurred considering that some of the official artists considered themselves revolutionary. Thomas Couture painted *Romans of the Decadence* as a critique of the constitutional monarchy. And when Gérôme painted *The Masked Ball* in 1867, the conservatives attacked him for his stark figures

and heavy use of black and white. As Cachin asserted, "*La prétendu frontière* between the 'good' and the 'bad' that had made some the great and others the *pompiers* is infinitely more movable and subtle than one had been saying for the last decades."[39]

Having concluded that both academic art and Impressionism accurately reflected nineteenth-century society in all of its own contradictions, the curators decided to exhibit both academic and nonacademic art. Cachin explained, "Not to show all the art is like a library not having the bad books."[40] Cachin wanted her museum to be complete. The academic artworks would be shown because they were painted at the same time as those of the Impressionists and the Realists, regardless of the curators' personal tastes. Curator Geneviève Lacambre concurred, "The art of fantasy is an historical fact."[41] Lacambre further argued that the showing of academic art was in no way related to the politics of the *conservateurs*. For example, Lacambre voted for the left in political elections yet was in charge of most of the academic art and is known for her research in salon art and the discovery of a lost painting by Cormon entitled *Caïn*. She dismissed those journalists who believed in a plot to rehabilitate academic art. Even Henri Zerner, who argued against the rehabilitation of the academics, approved of showing the Impressionist paintings with academic art in order to demonstrate that the Impressionists did not live or paint in a vacuum.[42]

The Jeu de Paume avoided the controversy in nineteenth-century art and the strife between the independent artists and the Academy by housing only Impressionist art. Art patrons of the nineteenth century were both the elite (who enjoyed the fantasy art of the *pompiers*) and the bourgeoisie (whose activities were portrayed by so many of the Impressionists).

The art of the nineteenth century consisted of both large, bombastic Salon paintings and smaller, more complex avant-garde

works. "Ultimately, the subject of Orsay is the democratization of taste in nineteenth-century Europe. It describes a crisis of authenticity in nineteenth-century cultural life," Perl wrote.[43] As Yvan Christ analogized, "*Fait esthétique = fait de société.*"[44] Barnaby Conrad, in *Smithsonian*, viewed the museum "as a hall of fame for all those who exhibited or tried to exhibit at the Salon."[45]

The museum also illustrated the battle that had faced the Impressionists, to show their art in the nineteenth century. One can now understand how innovative the Impressionist artists really were. Visitors to the Jeu de Paume may have appreciated the beauty of the Impressionists, but probably did not comprehend the extent of the differences separating Impressionists from their artistic adversaries. Visitors may even have left the Jeu de Paume assuming that all French art of the nineteenth century resembled the avant-garde. The curators at the Orsay allowed the visitor to make his or her own aesthetic judgment after viewing the different styles. The curators were accused of rewriting history by displaying the academics; in fact, they were trying to allow the full history to speak for itself.

Reestablishing the Hierarchy

The decision to exhibit academic art with Impressionist art was only the first step in the creation of the Musée d'Orsay. How and where each painting would hang in the museum was equally controversial. The arrangement of the museum separates the avant-garde from the academics. As mentioned above, the academic and salon artists are shown in the right aisle on the first

floor, while the Realists and early Impressionists are displayed in the left aisle. The visitor proceeds to the uppermost level under the roof of the booking hall to view the later Impressionists. The Post-Impressionists, Pont-Aven school, and Nabis are shown on the rooftop level. The last part of a typical visit of the painting collections is the second level where the remaining salon art is shown along with Naturalist works.

The layout of the museum gives some of its most prominent spaces to Salon art. In fact, the only painting to be hung in the main nave is Couture's *Romans of the Decadence*. This immense painting covers the entire wall of the mid-section of the train shed. *Los Angeles Times* reporter William Wilson, after describing its location, wrote that *Romans of the Decadence* "used to serve as an art history professor's favorite example of just how bad academic art could get."[46] Robert Hughes referred the painting as the "ancestor of all Cecil B. DeMille orgies."[47] In contrast to Couture's painting, Courbet's masterpieces are placed off to the side of the main nave where the light raking across them hampers viewing.

Placing Couture's painting as the focal point of the museum led artist Pierre Soulages to the conclusion that "Orsay shows the *pompiers* first and the rest of the art on the margins. It demonstrates the return of taste from the epoch."[48] Although the curators thought the Impressionists had the best position in its Galerie des Hauteurs, Januszczak disagreed. "Bouguereau, Couture, and Gérôme are hung more prominently than Gauguin, Van Gogh, and the Impressionists."[49] Zerner postulated that "maybe they [the curators] are not showing that many *pompiers*, but they are so big that they take up a significant portion of the building."[50]

Another viewpoint champions more integration of the schools. Patricia Mainardi criticized the curators for separating the two currents of art at all. She argued that "the issues and stresses of

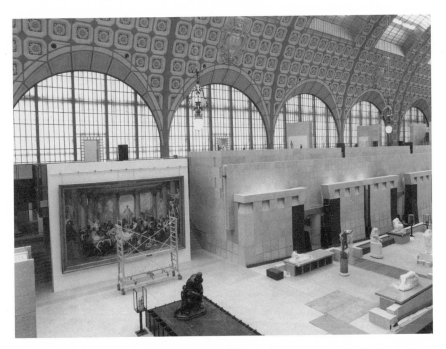

Fig. 19. Installation of *Romans of the Decadence* in the main hall.

the nineteenth century are rendered invisible through the compart-
mentalization and the distractions of a theme park spectacle. The
art is neutralized and emptied of its political meaning when the
confrontations are avoided."[51] She believed that if one was going
to show the academic art, the only proper way was to contrast it
directly with avant-garde art in order to illustrate its deficiencies.

Impressionism Is Still the Best

Ironically, after so persuasively arguing that academic art needed
to be shown in order to be both historically accurate and

nonjudgmental, the curators then asserted that there was indeed an art hierarchy. Laclotte responded, "It is blind to think that we are changing the hierarchy of art. The hierarchy is not at all denied. It is written in the space of the museum."[52] The Impressionists, whose paintings focus on the use of light, receive the best natural lighting in the museum; their rooms contrast sharply with the darker, more crowded rooms on the second level. Through the organization of the rooms, the manner in which the paintings were hung, and the lighting of the rooms, the curators believed that they had clearly established a hierarchy. Although the curators exhibited the academic art for a variety of reasons, they did not completely rehabilitate it. The avant-garde reasserted its prominence through the spatial hierarchies of the museum.

Cachin explained further, "There are two approaches of exhibition in a museum. One is more historical and comprehensive while the other is more conceptual and destined to impose a vision. At Orsay, we have chosen the first philosophy. The avant-garde is privileged but not tyrannical. Our role is to indicate a hierarchy of values but not to have a bigoted vision of the past."[53] Laclotte also appealed for caution when making grandiose statements about rehabilitation. "In more than one case this realignment of values remains debatable or unfinished. It is undeniable that it ignites, as with every flare up of fashion, the questionable enthusiasm of snobbery and speculation; not every artist in the process of reevaluation is a scandalously forgotten genius."[54] Cachin even agreed with critics of the *pompiers*: "Certainly we have bad paintings, but we have only the 'greatest' bad paintings."[55] The curators compromised; they displayed all art, but the space in the museum was used to reestablish the hierarchy.

The curators defended the museum's arrangement in two ways, by using light and space as a measure of a painting's importance.

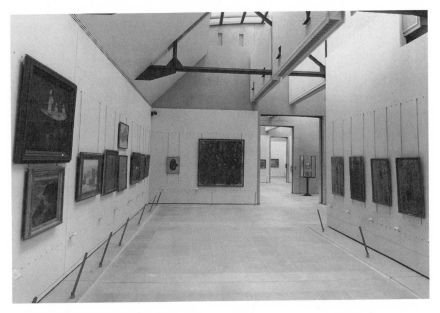

Fig. 20. Galerie des Hauteurs with Impressionist paintings. Note the skylights.

The curators contended that the Impressionists were given the best rooms in the museum because, in fact, it is the Galerie des Hauteurs that had the most natural lighting. The salon art is displayed in the darker, domed rooms on the middle level.[56] Laclotte clarified, "The fact of having put Cézanne, Gauguin, and Monet in the best light with a lot of space indicates out hierarchy."[57] Courbet, Ingres, Daumier, Van Gogh, and Cézanne are displayed in their own rooms, while no academic artist had a similar honor. Salon art is shown as it had been in the Salon, with one painting hung above another. Very few of the avant-garde paintings are actually displayed this way. In fact, John

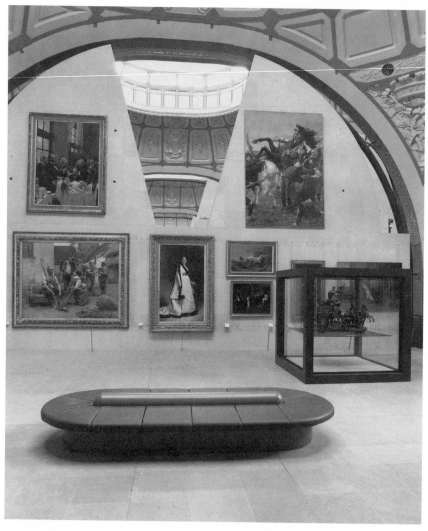

Fig. 21. Second-floor room with paintings hanging one above another, with original station ceiling design.

House complained that to place salon art in cramped rooms hurt them even more. The museum's organization perpetuated "the idea that they [salon paintings] are somehow bombastic and over-sized."[58]

While establishing a hierarchy, the hanging of the collection also demonstrated the chosen progression of styles of painting. The right aisle illustrates Ingres and Romanticism leading into the *pompiers*; the left, Realist art proceeds into early Impressionism. The curators designed the two different aisles to allow for comparison while keeping the schools separate. As Laclotte explained, "The works were separated. A royal route from Manet to Matisse, another for the academics."[59] Cachin outlined their philosophy: "Our second principle was not to mix the techniques or the styles. Couture is visible but Courbet has his own room. We did not want to compare or mix them. Cézanne is without comparison to Bouguereau. It is not a question of introducing equivalents in the hierarchy."[60] The curators feared that if they placed the paintings side by side, visitors might infer that the *pompiers* were now the artistic equals to the avant-garde paintings. Sympathizing with the curators, Gibson concluded, "The problem is how to show in the same building without ambiguity, important works and works that are not justified."[61]

The curators' solution was, first, to give what they thought were the best rooms and the best placement to the avant-garde, and, second, to maintain physical separation between the two opposing trends of the nineteenth century. Gibson later wrote, "The collection is historically encyclopedic but installed so tact-fully that, as the French would say, the napkins are never mixed up with the dishcloths."[62] "What emerges," determined John House, "is a retention of the traditional modernist canon as an objective measure of worth with a liberal minded broadening of

the scope of examination, in the confidence that the accepted hierarchies will prevail."[63] Jed Perl concluded, "The academic paintings will never again have the prestige they had one hundred years ago, and the fringe loonies who are claiming that Bouguereau is as great as Cézanne are not setting policy at museums like the Orsay, and probably never will."[64]

Perl's "fringe loonies" were clearly not making policy at the Musée d'Orsay. The curators balanced hierarchy with accuracy. They accepted that both types of art reflected nineteenth-century society, while they avoided making severe judgments on art similar to those made by the government one hundred years earlier. The curators realized that the two artistic styles were often interrelated and that it was more difficult to categorize the types of art than originally thought. Modern art receives the best rooms and only modern artists have individual rooms. The irony is that with the huge size and placement of *Romans of the Decadence* and the sculpture being displayed in the main nave, academic art does appear to be more important and appears more frequently in the museum's publicity photos. The first and last views of the museum are not of the Impressionists, but of the train shed filled with academic sculpture. This result is ironic, but not deliberate. The curators never planned to place the established hierarchy in jeopardy or open it to so much debate. To them, the arrangement of the museum itself clearly communicated that the avant-garde was superior to the Academy.

CHAPTER THREE

The Conception
of the Museum

If every cultural act is political, then Orsay is certainly
political—by virtue of what it does and does not contain,
by virtue of what it originally represented, and by shifts in
emphasis.
—Jean Jenger, *The Metamorphosis of a Monument*

I was there to make noise!
—Madeleine Rebérioux, January 25, 1988

The character of a museum results from more than just the col-
lections it houses. The types of services it offers to its visitors, its
educational programs, and its accessibility to the public also play
roles in creating a museum. The final confrontation in the Musée
d'Orsay was centered around what character the museum would
have. The decisions on architecture were made and the debate
over paintings and sculpture concluded in the early 1980s. The
final question to be resolved was: What other features, if any,
would the Orsay include in the museum?

Museum for the Elite or the Masses?

The Louvre was considered the bastion of high art and sophistication in France, while the Pompidou Center, with its many services and free entrance, was seen as exactly the opposite: a museum for the people. These two museums were at either end of the spectrum of defining a museum, either as a temple of art or an educational center. For example, prior to the Grand Louvre project, the Louvre did not post lengthy explanations with its collection; the collections in the museum were so extensive that visitor services were seen as superfluous. In contrast, the Pompidou Center consisted of much more than the Museum of Modern Art contained within it. The Pompidou Center library was one of the only public libraries in Paris. The outdoor plaza provided space for street performers and concerts. It was an integral part of a vibrant cultural quarter.

The Orsay evolved into neither a Louvre nor a Pompidou Center. The battle and the compromises reached over the conception of the museum, the historical explanations, the cultural services, and its multidisciplinary collection firmly placed the Musée d'Orsay in the middle of the museum spectrum. The Orsay became a museum of high art that takes education of the masses seriously.

The Beau Musée

The French government's initial proposals for the museum reflected a conservative sentiment. Former president Valéry Giscard d'Estaing viewed the Musée d'Orsay as his personal contribution to the cultural life of Paris. After watching Georges Pompidou attach his own name to a monument, Giscard wanted to do the same. Giscard's artistic preference, though, tended more toward high art and less toward the kind of popular culture presented at

the Pompidou Center. Giscard wanted the refined Orsay to coun-
terbalance the more common Beaubourg.

Located in the Seventh Arrondissement, a quarter filled with
ministries and old wealth, the Musée d'Orsay building was situ-
ated in a manner similar to the Louvre. Its location implied that
it was not designed to be a new center of broad cultural activity,
as was the Pompidou. Proposals from a few museum planners to
close street traffic on the quay side and create a plaza on the
Seine were overruled. The effort to create a pedestrian walkway
linking the Orsay with the Boulevard Saint-Germain also col-
lapsed. Giscard wanted the Musée d'Orsay to be a "beau"
museum on the scale of the Louvre, the Prado in Madrid, and
the National Gallery in London without the populist elements
of the Pompidou. As he argued, "With Delacroix, Corot, Courbet,
Manet, and Cézanne [the Orsay] will be just that."[1]

Giscard came under fire for his plans. Pierre Cabanne exclaimed
in 1979, "The museum is following the *mode rétro*";[2] a year later
he wrote, "It is very much the beautiful museum wanted by the
president, ultra-traditional and prestigious."[3] *Le Nouvel
Observateur* made the accusation that by limiting the architec-
tural choices for the exterior of the museum, Giscard "[made] Paris
bourgeois."[4] In fact, the proposal for the new museum of the nine-
teenth century had originally been passed in National Assembly
over the opposition of both Socialists and Communists. The left
wing thought that Giscard was attempting to create a monument
to himself and the elite culture of the nineteenth century.

Socialist Victory

The Socialist victory in 1981 completely changed the political
and cultural climate in France. After their victory, the Socialists
changed a wide variety of economic and social policies of the

French government. François Mitterrand was the first Socialist president since World War II and his government marked the first time that the Communists participated in the government. It was a true triumph of the left. The Orsay administration, so often attacked as conservative and not even supported by the left, wondered how they would fare under the new government.

Mitterrand visited the Orsay shortly after his election and approved of its activities. Politicians on the left tended to support cultural projects more than right-leaning politicians.[5] Moreover, the museum highlighted a period of French dominance in the arts. Mitterrand also admired Gae Aulenti's postmodern interior design.[6] Mitterrand, however, took one immediate and significant action in appointing social historian Madeleine Rebérioux as vice-president of the Établissement Public. Rebérioux had three responsibilities: watch over the Établissement on behalf of the government, infuse a sense of history into the Orsay, and attract a broader public to the museum.[7]

Rebérioux's presence in the museum had an immediate effect. The curators were forced to examine the place of history in an art museum as well as their own definition of the meaning of art. Rebérioux believed that art is only a form of history and that historical explanations should be available in a museum. This belief clearly contrasted with the curators' traditional conception of a museum in France. As Rebérioux saw it, the battle between her and the curators raised compelling questions: Was art or the history of the people more important? Was the latter necessary to understand the former? Was it the role of the museum to provide this education?

Rebérioux was also concerned with bringing more people to the museum. She concentrated her efforts on welcoming services in the museum and on alternative cultural activities that the

museum could offer. It was Rebérioux's plan that prompted Cabanne to proclaim in 1982 that the "*beau musée*" had been replaced by the "*grand musée.*"[8]

The majority of top curators in France have specialized training; in the École du Louvre, for example. One can distinguish curators by experience, outlook, and training from other professionals in the museum. While historians, particularly in the United States, may oversee antiquities or medieval art collections, professional curators in France are strictly used for post-Renaissance painting collections.

Rebérioux's appointment was the first time a historian was appointed to the administration of a major museum in France and she was determined to prove that historians played a valuable role. Maïten Bouisset declared in *Liberation* that Rebérioux's appointment was one of the most important innovations in the museum.[9] *Le Point* commentator Jean-Louis Ferrier wrote that Rebérioux brought the precious complement of history to the museum, allowing the comprehension of the entire epoch.[10]

Being so different from the typical museum curator or administrator in France, Rebérioux was eyed suspiciously. Rebérioux herself recognized that she created tension. "If I had not been leftist, had not been female, and had not been an historian, much less would have changed in the museum."[11] She remarked, "At first I had an image of the left but I tried to keep politics out of the museum. I did not want an image as an *agent politique.*"[12] Rebérioux also appeared more concerned with her role as a historian than part of the government.

But she understood her limits. She ruefully acknowledged, "My friends who rejoice that social movements will now be shown are under an illusion."[13] Rebérioux realized she had limited ability to change a museum that had been underway for four years.

Others realized this as well. Georges Beck, an official in the Ministry of Culture, noted that in 1981 the discussion of history in the museum and welcoming a new public were in vogue. Realistically, however, he concurred with Rebérioux, "We knew there would be some difficulties [putting our plans into practice]."[14]

History in the Museum

The argument between Rebérioux and the Orsay curators was rooted in a conception of the relationship of the museum to art history in France. Rebérioux viewed art as yet another record of society—much like she viewed literature, music, and dance. Rebérioux wanted to bring historical interpretation out of the classroom and into the museum.

Museum as Educator

There were two logics to art museums, Rebérioux claimed. "One is to present the paintings to enjoy, the other is to present them to understand."[15] Her belief was that one could enjoy *and* understand a painting. In order to place an artwork in context, however, most people required an explanation of some sort. Rebérioux wanted the museum to supply explanations that would discuss the different art currents of the nineteenth century and the importance of changes in the art world. She argued that the public would better comprehend art if they understood the battle between modern art and the Academy. The Orsay would not only provide a visual record of the different art, but it would also provide an education about art.

Rebérioux wished to establish a *"correspondance des arts,"* where the museum would link art to simultaneous trends in literature and music. She believed that this educational program would, in turn, support the goal of bringing a new public to the museum. "Putting works in relation to the history of society will make it more comprehensible to everyone."[16]

Rebérioux also wanted the museum's historical approach to cover more than just the art world. To Rebérioux, the real conflicts of the nineteenth century were not between the Academy and the Impressionists but between the workers and the upperclass. The debate in the art world merely reflected the concerns of the social classes and their respective aesthetic tastes and views of the state. Historical interpretations of the pieces could explain this context to the visitor.

In order to bring in more of the industrial world, Rebérioux proposed the display of industrial objects near the paintings. The actual objects would correspond to their representation in each painting. To better understand Daumier's laundress, for example, Rebérioux wanted to show a contemporary laundry basket or an iron. She commented, "Industrial objects have their own beauty. While some [academic] art can be understood without the knowledge of industrialization, it is essential for other types [of art]."[17] She argued that such objects would give a better sense of the total society and would also attract more people. Engineers and workers, typically less interested in an art museum, would be interested by presentations concerned with industrial development.

The curators, on the other hand, believed that an art museum existed for the formal analysis of art, examining style, colors, use of shadow and light, size, brushstroke, and subject matter. A work's historical importance or significance came only from this inquiry. A painting was revolutionary when it changed one of

these major factors, and it was these elements that distinguished one school of art from another. For the traditional analyst, the Impressionists were independent because they were innovative in paint application, subject matter, and palette rather than because they were not shown in the Salon and often politically active.

This battle of formal analysis versus sociohistorical interpretation is also reflected in universities with arguments between more traditional art historians and social art historians. The latter group wants to bring economic and political history into the art classroom. While social art historians do not wish to eliminate formal analysis, they feel that a more complete study of art is made with the inclusion of history in the art course. The "social history of art . . . challenge[s] once and for all the notion that the art work can exist in some totally independent realms of visual values."[18]

Thus, many art history classes today cover more than a particular style of art or even the personal lives of the artists. These courses examine the society in which the artist existed and the political influences that affected his choice of subject matter and style of painting. For some modern paintings, such as Picasso's *Guernica*, a sociohistorical study seems mandatory, not indulgent. Rebérioux argued that this type of analysis was also appropriate for nineteenth-century art. The curators and the government had to clarify the Orsay's purpose: Was it to provide an art education or art enjoyment?

Museum As a Temple

In the end, the curators were successful in keeping the core of the Musée d'Orsay as a temple of high art. Lacambre explained, "We [the curators] refused to view the museum as an illustrated history

book."[19] Dominique Ponau, the director of the École du Louvre, explained that curators are trained to have the philosophy that "the museum is a place for contemplation, not for explanation."[20]

That the curators felt embattled can be seen from Cachin's numerous statements in a variety of interviews. "Rebérioux tried without success to influence our program so that each work would be shown in its sociological context."[21] "How could we have put more history into the museum?" Cachin asked. "It is not a book."[22] Besides, she argued, "The entire museum is a history lesson."[23] House concluded, "The curator attitude is that every object was chosen for its aesthetic quality. It denies any real history of the art's creation and purpose."[24] Établissement Public Director Jean Jenger commented from his supervisory role that the curators were reactionary when faced with Rebérioux's proposals and had no conception of displaying art with historic exhibits.[25]

One way for the Orsay to have incorporated Rebérioux's proposals would have been to create galleries that reflect how a typical room or artist's studio would have appeared at a particular period in history. Many museums are particularly renowned for their period rooms. The curators at the Orsay decided against creating a series of period rooms, only restoring the ballroom of the hotel to its original decor. Laclotte emphasized that the Musée d'Orsay was not a museum of sociology and that neither period rooms nor the recreation of an artist's studio would be used.[26]

The displays in the museum ignored industrial development. Mass culture was sacrificed as well: the inferior displays concerning posters, photography, and cinema in the museum demonstrated an emphasis on elite culture.[27] Rebérioux pointed out that the curators created a distinction between nineteenth-century art and industry that did not exist at the time. When Antonin Proust was named as a government minister under Gambetta in 1881, he was the *Ministre des Arts* (Minister of the

Fig. 22. The restored ballroom, the only period room in the museum.

Arts)—recognizing a plurality of artistic mediums and values—
and not the *Ministre de l'Art* (Minister of Art). Although the
Third Republic did not separate the different types of creative
production into a hierarchy, the curators of the Musée d'Orsay
retrospectively instituted one for the art of the Third Republic.

Rebérioux's Successes

Despite the curators' staunch opposition, Rebérioux instituted
several innovations in the museum. Although the historical dis-
plays were not well integrated into the collection, their very

existence was a breakthrough for French museology. Ferrier wrote of Rebérioux's tenure, "One can watch the appearance of the republican ideas and of the culture of science and the idea of progress in the museum."[28]

The "Pages of the Musée d'Orsay" provide some explanations of the art in general and of nineteenth-century society. These laminated pages are arranged in a display case where each can be read and returned. The pages are available throughout most of the museum, although they are not prominently located in most rooms; nonetheless, they provide the type of historical explanation Rebérioux desired. The presentation is colorful, animated, and attractive. In their study on French culture, sociologists Pierre Bourdieu and Alain Darbel demonstrated that the public preferred not to ask questions, but to have explanations simply available.[29] The "Pages of the Musée d'Orsay" clearly meets the need for information provided in the least burdensome manner.

Rebérioux's concerns were also reflected in the creation of the Gallery of Dates, a audiovisual display located in a passageway at the front of the museum, behind the grand clock. The interactive medium covers the period 1848 to 1914 and contains information about topics ranging from politics and diplomacy to music and literature. The visitor can choose a year and press buttons on the screen to select topics and gather the information. This system is truly a modern learning mechanism and clearly expands the museum beyond high art. By using this form of communication, the museum gears its learning facilities to the less well-read and the young.

The Gallery of the Press, located in the passageway directly below the Gallery of Dates, presents the development of the free press in France. The display highlights the importance of the growth of newspapers for the entire population. It also covers the development of the regional papers and the first penny press. The

evolution of the free press marked the emergence of mass communication and has been linked with the social upheavals at the end of the century. Rebérioux's interest in discussing the turmoil of the nineteenth century is clearly apparent in this display.

Rebérioux also used a program of temporary exhibitions to bring more history into the museum. These exhibitions were often historical inquiries into a work of art. For example, an exhibition in January 1988 featured Fantin-Latour's *Coin de Table*, a painting portraying many famous writers and artists, including poets Arthur Rimbaud and Paul Verlaine. Through its display and audiovisual aids, the exhibition explained the life and work of each of writer in the painting. In one audiovisual, the people in the painting became animated and continued the story of the relationships among the artist and the poet, politician, writer, and others. In 1992, the Orsay hosted an exhibition on Beatrix Potter's *Peter Rabbit* linking art and children's literature. These exhibitions continue to examine art in its historical context and relate it to the rest of society.

Rebérioux's least successful display in the museum was her "*Ouverture sur l'Histoire*" (Opening on history). This small display case, located in the lower level to the left of the entrance, holds clothes, letters, and other memorabilia from 1848 and was intended to convey the excitement of the 1848 revolution. Rebérioux wanted this display to be elaborate and placed at the entrance of the museum in order to introduce history at the outset of a patron's visit. In contrast to Rebérioux's other projects, where she succeeded in making the history display animated and informative, the "*Ouverture sur l'Histoire*" is badly placed and relatively uninteresting. In fact, she herself jokingly referred to the display as the "*Fermeture sur l'Histoire*" (Closing on history).[30]

While Rebérioux was pleased with the history that was brought into the museum, she would have preferred to have done more.

"It is an admirable force in museology when it takes history into its arms. Why did it stop halfway?" she asked.[31] House concurred that the core displays did not reflect Rebérioux's presence. History was relegated to the marginal corridors.[32] The curators, however, believed that these innovations, even if they were on the margin, were more than other art museums had done in the past. They provided the history without interfering with the display of art. And, as Grace Glueck commented, the Orsay, "though now watered down to accommodate both traditional and revisionist approaches, was born of the notion that art relates to the historical, social, and political forces of its era."[33]

Welcoming a New Public

Daniel Sherman wrote that the creation of museums in nineteenth-century France was fueled by the middle class's desire to participate in culture.[34] Yet the need to expand the museum-going population was obvious. A *Quotidien de Paris* poll in 1985 showed that 40 percent of the French population had never been in a museum, 42 percent rarely visit a museum, and only 18 percent of the population considered themselves frequent museum visitors. Moreover, a poll taken from July 1978 to May 1979 among visitors to the museums in Paris showed that only 0.5 percent of the visitors were farmers and only 3 percent were manual laborers. Even at the Pompidou Center, the most communal of all museums in Paris, only 6 percent of its visitors were manual laborers or craftsmen.[35]

Even before the decision was made to create the Musée d' Orsay, the Ministry of Culture recognized the need to broaden the base of museum-goers in France. While in the Ministry of Culture,

Établissement Public president Jacques Rigaud wrote that the primary goals for the Ministry were to foster multidisciplinary arts, stimulate the use of heritage, and allow more people to enjoy culture.[36] A decree in 1979 stated that the task of the Ministry of Culture was "making accessible those outstanding works of art of international—and, above all, French—importance, to the greatest number of French people and to ensure the greatest audience for our cultural heritage," repeating exactly the words that André Malraux, the first French minister of culture, had used twenty years earlier.[37]

The desire in France to broaden the viewing public of the Musée d' Orsay was not limited by party or political affiliation. Jacques Chirac proclaimed that a museum should conform to the Gaullist idea of a civic conscience.[38] Mitterrand stated many times that he wanted the Orsay to be visited by more a diverse public. Even Rebérioux admitted that she did not transform a museum of the right into a museum of the left through this cultural service program.[39] As one official publication of the Musée d'Orsay affirmed, "The ambition of the museum is to permit the visitor to find responses to his curiosity and to touch a new public, larger than the usual public of the museums."[40] Although the curators were against an active cultural service because it would fall outside of their expertise, the government's desire prevailed.[41] The power of bipartisan backing for increased visitor services overcame bureaucratic hesitations.

Visitor Services

Pierre Bourdieu, Michel Certeau, and other French sociologists argued that a lack of cultural education was the primary reason French workers did not share the elite culture. Bourdieu cited a

poll that showed 80 percent of French workers felt that a museum was like a church—a place to respect but not to enjoy. In contrast, 50 percent of middle class and only 35 percent of the upper class held the same sentiment.[42] Certeau hypothesized that the difference in attitude toward museums between the elite and the masses was *"ce qui se pense et ce qui se passe"* (those who think and those who pass).[43]

Rebérioux argued that it was necessary to begin cultural education as soon as possible.[44] Compared to that of the Louvre, which the public often found intimidating,[45] the goal of the Orsay was to make the museum more accessible. The Orsay tried to fix the problem at its roots by educating all French children in high art and demonstrating to them that a museum could be enjoyable.

A separate welcome area for children is located below the main hall in the Orsay. The room has easels and chalkboards, as well as explanations about painting and other forms of art. Tours geared for children and school groups are run on a regular basis. Furthermore, bringing elementary school groups into the museum assures that children from all socioeconomic classes are exposed to art before they reach high school and university. (The relatively uniform primary education French children receive contrasts sharply with the educational hierarchy at the high school and university levels.) By the time the Musée d'Orsay was opened to the public in December 1986, more than 1,500 schoolchildren were scheduled to visit it.[46]

The museum targeted the teenager and scholar through student prices and an extensive research center. This research center became one of the premier locales to research nineteenth-century art. In addition to its abundant literature, the museum opened a video bank of over 12,000 images that filled gaps in the museum's collection of artists, schools, or certain techniques. Even if the museum did not have a particular painting in its own

collection, a student could search for it through the holdings of other museums on video.

While these two projects were directed toward education of the young, Rebérioux's most important innovation that was designed to draw new groups into the museum was her early contact with labor unions and companies around Paris. This program was significant not only because it included the unions but also because Rebérioux contacted companies in the suburbs of Paris where people were traditionally alienated from Parisian culture. Under this program, companies can underwrite a special Carte Blanche museum membership for their employees. Also available to individual citizens, it provides free admission to the museum and all its conferences, special exhibitions, and concerts. The museum is open one evening a week so that people can go after they leave the office.

This attention to the worker was unique in French museology. It created an alternative means for companies to be civically involved. The Carte Blanche membership and group tours provide French companies an attractive bonus they could offer their workers. The Orsay was also the first museum in France that had corporate sponsorship of its special exhibits.

The cultural services provided by the Orsay include programs of music, film, and literature. The steady rotation of concerts, courses, conferences, and temporary exhibits prevent the museum collection from stagnating, and continually attract new people to the museum. These programs bring more history into the museum and create a cultural center of the nineteenth century. By showing films on the period and playing music composed at the end of the century, the museum provides the broader understanding of art for which Rebérioux had fought so hard. The program themes are organized around the art and its relation to the literary or political dilemma of the day. Giscard explained, "For the first

time, the public will be able to see the linkages between art and literature such as those between Monet, Mallarmé, Proust, and Debussy."[47] In fact, an exhibition in 1989 focused on the links between Stéphane Mallarmé's poem "L'Après-Midi d'un Faune," Claude Debussy's score "Prélude à l'Après-Midi d'un Faune," and Russian Vaslav Nijinsky's ballet choreography to the score.

Rebérioux believed that the cultural service was her principal contribution to the museum. The museum became not only a place to view art but a place of active learning. Although Rebérioux acknowledged that she made a difference in the displays of history, she was most proud of the cultural service that she felt would have a more enduring impact.[48] In fact, the cultural service in the Musée d'Orsay became the model for the cultural service in the Grand Louvre project and will no doubt be copied by future museum administrations.

Innovations in the Collection

Augustin Girard, in a UNESCO study, noted two ways of increasing the museum-going population: democratizing high culture and creating a cultural democracy.[49] The Orsay's attempts to attract more people to the museum responded to Girard's first suggestion by making high art (painting and sculpture) more available to the public. Broadening the collection beyond painting and sculpture addressed his second proposal.

A French Ministry of Culture study in 1983 found that "the myth of the democratization of culture is the myth of the existence of a homogeneous population which is receptive to a universal culture."[50] In order to raise the percentage of the popu-

lation that was interested in French culture, the group suggested expanding the definition of culture to embrace the popular, the technical, and the regional. Building a culture *au pluriel* (for all) meant placing it *au quotidien* (as part of a regular routine).[51] Although the curators refused to display industrial objects with the art, the definition of high culture was expanded in the Orsay through additions to the collection such as photography, decorative arts, architectural plans, and film.

A Multidisciplinary Approach

The Musée d'Orsay has been praised universally for encompassing more than high art.[52] The multidisciplinary approach of the museum was demonstrated by the fact that decorative arts and furniture had their own rooms. Previously, furniture and objets d'art were only exhibited in period rooms. Relegating all artwork other than painting and sculpture to limited period rooms or other museums sent the message that these types of art were not considered important. Showing decorative arts and furniture in their own display consecrated them as independent art forms. This innovation declared that these arts were suitable for a grand art museum. The inclusion of other art in the museum represented a liberalization among curators and other cultural elites and was politically important because these arts were more closely associated with popular culture than the elite.

This multidisciplinary approach commenced with the initial plans for the museum. Despite accusations against him that he was creating a museum for the elite, Giscard approved these innovations. Mitterrand highlighted this multidisciplinary approach as one of the reasons he approved the museum. Even the curators wanted to exhibit these new art forms. Cachin ex-

plained, "Art nouveau was not bought or shown by museums in general and photography was hardly shown in Parisian museums."[53] Especially since much of the history of photography is French, the curators felt it was necessary to consecrate this accomplishment in a museum that covered the nineteenth century.

Support from both sides of the political spectrum was manifested in the acquisition policy of the curators. Between 1978 and the museum's opening in 1986, the Orsay procured 270 paintings, 280 sculptures, 555 objets d'art, and over 1,000 photos. While the Orsay could build on the collection in the Louvre and the Jeu de Paume for its paintings and sculptures, other areas of the collection had to be built virtually from scratch.[54]

The reevaluation of photography as an art form was particularly obvious. Photography had its own two curators who built the entire collection with money assigned to them in the Orsay budget. In addition to three rooms permanently devoted to it, photography would also be the subject of yearly exhibitions on a particular theme. The collection in the Orsay covers the beginning of photography in 1839 through 1915 when modern photography began with New York's secessionist movement. *Le Figaro*'s Chevrier praised, "It is the first time in France that old photos are assembled in a manner that shows the history and progression of photography." Furthermore, he explained, "The inclusion of photography, architecture, and film makes the museum more than just the department of painting and the department of sculpture from the Louvre. It covers all areas of Beaux-Arts."[55] Since photography is an art form available and understandable to most of the population, this is a true expansion of the scope of art.

One of the most original displays in the Musée d'Orsay is the multimedia presentation of Garnier's Paris Opera House as part of the architectural displays in a side room on the first floor.

Theatrical designer Richard Peduzzi arranged a cutaway model of the opera house with mock-ups of the most memorable set designs placed in the wall. In addition, the exhibition includes a 1:100 scale model of the neighborhood surrounding the opera house placed under a transparent floor where visitors walk over the model.

The Musée d'Orsay was also innovative in its display of foreign schools of art. "A visitor to the Jeu de Paume would think that all art of the nineteenth century was French," stated Michel Laclotte.[56] The Orsay attempted to correct this impression by showing the offspring of French art and some of concurrent artistic trends in other countries. Russian, Italian, Belgian, Swiss, British, American, and Austrian artists are represented by a variety of works in the museum, some of which have never been seen before they had been displayed there.

This display of foreign art was also derived from the desire to demonstrate how France was the center of the cultural world in the nineteenth century. Mitterrand's building plans for the center of Paris, such as the Musée d'Orsay and the Opera House, stemmed from the desire to enhance French cultural life and show off the areas where France was considered to be the best in the world. It has rarely been disputed that French art dominated the nineteenth century. The display of foreign art was both interesting aesthetically and served as another reminder that French art was the standard to which all others aspired.

The multidisciplinary approach in the museum was reflected in its administration as well. Établissement Public Director Jean Jenger explained that, unlike the Louvre, there was no departmentalization by artistic medium at the Musée d'Orsay, demonstrating that "between 1848 and 1914, the arts were inter-meshed, inter-linked and cross-fertilizing."[57] The influence of photography on the Impressionists was only one such example.

The Orsay's new collections, however, are not mixed with the permanent ones of painting and sculpture. Although there are furniture rooms, these are at the end of the visit. Because the museum is so big, many people miss these rooms (as they do those of the salon art, also on the second floor). Lascault agreed, "If the program of the museum was to mix painting, sculpture, and furniture, then the organization of the rooms tends to reestablish the separation of the works and a hierarchy of arts."[58] It was another compromise in the collection.

Nonetheless, in the case of the Musée d'Orsay, we can see that the conception of a museum changed the historic definitions of a museum. The Musée d'Orsay became more than a museum of high art. The presence of historical explanations in the museum was near revolutionary at the time, even if they were on the periphery. The extensive network of communications with schools and companies in order to bring more people into the museum was also a grand innovation. It directly addressed the needs of a public in which only a small percentage of people participate in the rich cultural heritage of France. Finally, the museum enlarged the definition of high art. Although industrial objects were still not considered pieces of art, photography, architectural plans, and furniture were exhibited. Rebérioux was able to change the museum on the periphery and in areas where the curators lacked expertise. The expanded collection was a bipartisan desire shared by the curators. The definition of elite culture was at least expanded to the new limits set by the cultural elite.

Mixed Signals

What we see and do not see in our most prestigious art museums—and on what terms and whose authority we do or don't see it—involves the much larger questions of who constitutes the community and who shall exercise the power to define its identity. —Carol Duncan

The acquisition policy of a museum is never innocent. It reflects a taste and it determines the direction of taste.
 —Jacques Thuillier

The Influence of the Musée d'Orsay

It is clear that major art museums can exert influence over other museums as well as the art market.[1] Since the opening of the Musée d'Orsay in 1986, it no doubt has had an impact. Just as François Mitterrand intended, museums in the center of Paris spawned effects. Like rings formed from throwing a stone into a pond, these effects ripple over a large area.

The actors in the Orsay drama moved on. Françoise Cachin became the director of the Orsay, Michel Laclotte went back to the Louvre, Madeleine Rebérioux returned to teaching, Gae Aulenti traveled to Barcelona to redesign the National Museum of Catalan Art, Jean Jenger became the director of Documentation Française, and ACT continued its architectural business. President Mitterrand was replaced by a co-author of the Musée d'Orsay project, Jacques Chirac. Yet the impact and effects of the Orsay continued to be felt.

The Musée d'Orsay signaled new heights for postmodern interior design for museums that included the Neue Staatsgalerie in Stuttgart and the Museum of Contemporary Art in Los Angeles. Other museums commissioned postmodern interiors and found ways to reuse older buildings. The National Museum of Catalan Art, also designed by Aulenti, transformed a palace into an art museum. The sculpture-filled entrance to the Tate Galleries in London resembled the Orsay's. And the French government learned from its own success: the cultural service established by the Musée d'Orsay was copied by the Grand Louvre project.

The influence of major museums on the art they display should also not be underestimated. As Stephen Weil wrote of the effect a major museum can have:

> For example, an announcement that the Museum of Modern Art would, in three years, stage a major exhibition of flower paintings executed on black velvet in acrylic would not be without feedback in the art community. . . . There would be artists across the country who, looking into their souls, discover there a long-suppressed desire to paint acrylic flowers on black velvet. Museums, at such moments, no longer reflect art history; they take a large hand in making it.[2]

While there was already a trend toward a revival of academic art, the display of academic art with Impressionist art in the Orsay has encouraged other museums around the world to exhibit these paintings in their permanent collections. In 1981, the Andre Meyer Galleries in the Metropolitan Museum of Art in New York opened a section of salon art, while other smaller museums have held temporary exhibitions solely devoted to these rehabilitated artists since the 1970s.

Nonetheless, the permanent exhibition at the Orsay had a clear influence on both the painting and sculpture markets, where prices for academic art continue to increase steadily. For example, Christie's auction house devoted an entire catalogue to French academic art in 1997 and earned over 3 million pounds (close to $5 million) for its auctioned art.[3] As Robert Kashey, owner of Shepard's Gallery in Manhattan, stated, "Good and bad have been weeded out in a century of looking back at these works, enabling us to view the artists without prejudice, in a way that wasn't possible before."[4]

Most important, the Orsay influenced its visitors. Each decision taken in the museum sent a message about what was valued and what was not. From the dates of the collection to the historical explanations, from the actual works displayed to the way it is displayed, the Orsay conveyed a value system. Susan Vogel explains:

> The museum [in general] is teaching—expressly, as part of an education program and an articulated agenda, but also subtly, almost unconsciously—a system of highly political values expressed not only in the style of the presentation but in myriad facets of its operation. . . . The museum communicates values in the types of programs it chooses to

present and in the audiences it addresses, in the size of staff departments and the emphasis they are given, in the selection of objects for acquisition, and more concretely in the location of displays in the building and the subtleties of lighting and label copy. None of these things is neutral. None is overt. All tell the audience what to think beyond what the museum ostensibly is teaching.[5]

Compromise and Reconciliation

Any new monument that has the possibility of influencing future museums and scores of visitors will be critically examined, and one in the heart of Paris that holds some of the most popular art in the world will be scrutinized even more closely. Through this scrutiny, the Orsay ran the gamut of French abuse with accusations of ugly architecture, rehabilitation, partisanship, insufficient judgment, and the attempt to rewrite history. The battles over architecture, art, and the conception of the museum have been resolved, yet the museum remains controversial.

The amount of criticism received by the Orsay reflected the fact that the Musée d'Orsay did not make one single statement. Nineteenth-century architecture, art, and history were actually and metaphorically to be seen through the lens of a twentieth-century value system. And this translation from one century to the next was, in each case, a result of compromise.

If the neoconservatives could have designed the museum without compromising, they would have chosen a complete renovation of the station and a preservation of the Beaux-Arts interior. The *pompiers* would have been shown more prominently in the museum, and the innovations in the cultural service might not have occurred. On the other hand, if the radicals could have designed

the museum without compromising, they would have knocked down the Gare d'Orsay and built a new building. The postmodern interior in the restored Gare d'Orsay was already a compromise to the radicals. The *pompiers* would have remained out of sight in the reserves. Industrial objects would have been shown in the museum and each piece of art would have had its own historic explanation of its creation and its artist. The Orsay would have become a new cultural center. In the end, neither the conservative nor the radical viewpoint dominated the creation of the Musée d'Orsay.

The different priorities of all parties involved in the Musée d'Orsay project were also apparent in the plans for the museum. The government either needed to restore the Gare d'Orsay or erect a building on the banks of the Seine that would be suitable. The administration of the Musées de France needed space for nineteenth-century art. Although the decision by the government to save the Gare d'Orsay and build a museum within it avoided the problem of building a new structure, it left the interior design to be determined later. Once the administrative power passed to the curators, the rehabilitation of Beaux-Arts architecture was overridden. The curators' goal was the creation of a museum. The postmodern interior allowed the visitor to see the nineteenth-century architecture and its ornate decorations only through the breaks in the interior design and made it clear that the curators and Gae Aulenti did not admire the Beaux-Arts style. The Orsay made its own modern statement about architecture and museum building.

The period represented by the museum was a compromise among Giscard's personal taste, the Louvre's administrative constraints, the curators, and Madeleine Rebérioux. The choice of 1848 as a beginning date allowed some of the Romantics to be shown in the museum without forcing the transfer of large numbers of paintings from the Louvre. It also provided an alternative

to 1863, a date only relevant to French painting. Most important, 1848 highlights the republican form of government and conveys the importance of the Realists to modern art.

Compromise and reconciliation were apparent in the decision to exhibit some academic art. This art was first lauded at the expense of the avant-garde in the nineteenth century and then condemned to the Louvre reserves for most of the twentieth century. The Orsay curators reunited the concurrent styles of art in a single museum and corrected the mistaken policy of presenting only one or the other type of art. Yet this display was an accommodation rather than a rehabilitation. Although critics have accused the museum of attempting to reinterpret history, the curators were more inclusive in that history. The museum showed more art, but left the previous hierarchy intact. The curators did not attempt to change the established artistic judgments and, in fact, reinforced them through the layout of the museum.

The program of the Musée d'Orsay was a hybrid of the programs of the Louvre and the Pompidou Center. Prior to the Grand Louvre project, the Louvre attracted the cultural elite while the Pompidou was geared toward the masses and popular culture. The Orsay forged a middle route between the two. While maintaining that high art was superior, the curators were willing to provide explanations for the art and include some historic displays in the museum. Other kinds of art in addition to painting and sculpture were shown in the museum. The Musée d'Orsay made a true effort to attract more than the usual visiting public of museums. By welcoming school groups, the Orsay educated the population in elite culture. By attracting workers and companies, the museum rectified past inequities in cultural education. The additional cultural programs enhanced the historical context of the museum while bringing even more people to it.

Each museum decision and each value it represented was debated, contested, and rebutted. Each of the battles in the Orsay was resolved by compromise and negotiation, not through unconditional surrender to one vision or another. Therefore, the Orsay was neither revolutionary nor reactionary. The resulting values it conveyed were not always clear. Michael Brenson wrote that the Orsay sent so many mixed signals, the effect was painful.[6] Patricia Mainardi noted, "If a camel is a horse drawn by a committee, then the Musée d'Orsay is a camel of a museum."[7]

Shifting Political Sands

The Orsay's mixed signals in part resulted from the shifting political situation in France. Conservative President Giscard d'Estaing first set out the plans for the Musée d'Orsay. But it was up to Socialist President Mitterrand to carry these out. Some elements of the museum were changed because of this transition, such as the appointment of Madeleine Rebérioux. Similarly, other elements over which there may perhaps have been an argument, such as the postmodern interior and the 1848 beginning date for the collection, were quickly agreed to by the Socialist government.

Clearly, there were personal differences between each president's artistic tastes and their goals for the museum. Yet it is noteworthy that, contrary to François Chaslin's belief that new presidents try to eliminate previous presidents' projects, Mitterrand fully supported the Musée d'Orsay. In fact, during the 1980s, the Musée d'Orsay was linked with Mitterand's building plans for the city of Paris rather than remembered as a Giscard's project. Only since then has the Musée d'Orsay been

attributed to Giscard while Mitterrand has received more publicity for the Grand Louvre pyramid, in addition to the Opera, the Bibliothèque, and other projects.

The Orsay opened in December 1986, shortly after the elections in France forced Mitterrand to appoint conservative Paris mayor Jacques Chirac as prime minister. This sharing of power between the parties has become known as cohabitation. Yet the museum had already demonstrated that cooperation between the parties was possible and even successful. In fact, several reviews of the museum called the Musée d'Orsay the "museum of cohabitation."

The success of the Musée d'Orsay may be seen in sharp contrast to the Bastille Opera project. Shortly after Chirac was named prime minister in 1986, he halted the Opera's building plans in the name of austerity. Only lobbying by Chirac's own minister of culture, François Leotard, got the project moving again in 1987. Switches in power and control at the time of the Opera resulted in complete disarray in its planning and recruiting efforts, as well as the eventual departure of its initial director, Daniel Barenboim. As Jacques Rigaud noted, "I think it is without precedent as an example of the bad handling of a public undertaking. Projects of great dimension can be seen through only with a strong political will."[8] The Musée d'Orsay has remained a cogent reminder of what a government can accomplish despite political differences.

Curatorial Power

Another explanation for the museum's mixed signals stems from the relationship between the French government and the Musée d'Orsay curators. Almost every decision about the museum re-

quired the elected government and the museum bureaucracy to work together. Quite dramatically, the story of the museum reflects the power of the curators even in the face of strong presidential wishes. In the face of changing outside electoral politics, the curators held their positions, while the presidents, cultural ministers, and government officials moved on to other endeavors. The ongoing presence of the curators provided continuity for the museum and allowed the curators to anchor their goals.

The curators requested a different architect for the interior design of the museum and supported Gae Aulenti. In each change of plans, the design moved further from the initial government plan to fully restore the building. The museum sent a mixed message because there were two different messengers: the first, the architectural plan supported by the government, and the second, the more successful Aulenti, supported by the curators.

These mixed messages were also apparent in the placement of history in the museum. Despite the fact that Rebérioux had the support of the popular Socialist government, the curators successfully limited her innovations in the museum to the periphery. History was seen as important but not crucial to the museum. Similarly, the dates of the collection were clear compromises between the government and the curators, conveying both artistic and historic messages. Only the bipartisan goal of increasing museum attendance was able to overcome curator resistance and send a clear message to the public. In this area, where the curators were not familiar with the cultural service, Rebérioux established a truly original and resourceful program.

Although some reviews criticized the display of academic art based on political interpretations, these decisions did not involve a battle between the government and the curators. The display of academic art in the Orsay, however, highlighted the power of curators to affect taste and judgment throughout the world.

Former director of the Cleveland Museum of Art, Sherman E. Lee, has written: "We have our exalted *and* selective idea of the past precisely because we see it filtered though generations of connoisseurs."[9] The Orsay curators chose to include the academic artists, despite the inevitable press criticism. The curators also had complete control over the layout of the museum. This power of the curator to determine the collection has not been limited to France. Beverly Wolff, former legal counsel to the Museum of Modern Art in New York wrote, "[F]rom a museum's point of view, the curator's determination is paramount. . . . curators are empowered by us to make those decisions of what is art."[10]

Roles of a Museum

Another part of the explanation for the mixed signals lies in the contradictory roles of a museum. Stephen Weil, deputy director of the Hirshhorn Museum, has written that the roles a museum plays in society can be quite varied.[11] And when these roles conflict, curators and governments face difficult decisions. For example, a museum can function as a chronicler, displaying art as a record of past society. This role implies little aesthetic judgment on the part of the museum but rather that the museum displays selected pieces of art because the art is typical of an artist or period. On the other hand, a museum can play the role of a connoisseur, where the curator relies on aesthetic judgment in choosing pieces of work to display. In this case, the function of the museum, therefore, would be to provide and demonstrate the best taste in art. Many museum curators find themselves in this tug of war between journalism and connoisseurship. While a museum may show certain artists because their work is interesting or representative of a certain genre, it is difficult to convey

to a visitor the difference between art shown for this reason and art selected because of its "quality."

This tug of war is reflected in the Orsay curators' decision to display academic art. On one hand, the art should have been shown because it existed. As Cachin herself analogized, a library should have all books, even if they are bad. This role implies that the viewer judges the art. "[T]he aim of the Orsay is to let people judge by themselves, and decide for themselves what is good and what is not."[12]

On the other hand, a museum can convey a judgment about the art it displays. In the Orsay, the curators used the layout of the museum to function as connoisseur. By giving more space and more light to the avant-garde, the curators imparted their taste and highlighted the art they thought was best. The message of the museum was confused because the curators tried to have the museum play two conflicting roles. Laclotte referred to a "royal route" in the museum and Cachin insisted that the Orsay had only the greatest "bad" art. At the same time, both tried to allow the visitor judge for himself. They tried to balance hierarchy with accuracy, connoisseurship with journalism, but only partially succeeded in being clear about their messages.

Another set of conflicting roles for a museum is the museum as a temple of contemplation versus the museum as an educator. These roles came to the surface in the debate about the role of history in the Orsay. The curators' view was that the art needed no further introduction. Visitors arrive at the museum and quietly contemplate the art using the traditional formal analysis. In fact, museums constructed before the second half of the twentieth century almost always resemble Greco-Roman temples with columns with courtyards to increase the majesty of the museum. Ironically, it is this successful construction of the art temple that also intimidates and limits the viewing public.

The alternative view is the museum as an educator. Many museums in their charter refer to education as a primary goal. For example, when the Metropolitan Museum of Art opened in 1870, diplomat and Rockefeller family lawyer Joseph Choate outlined its purpose as "to humanize, to educate, and to refine a practical and laborious people."[13] But the question remains of who is to be educated. The Louvre was originally established for art students, not the general public, and was only open three out of every ten days to the public. The uproar over the Barnes Collection in Philadelphia, only recently sent on its first public tour, demonstrates the debate over who should have access to the great works of art.[14]

Educator was clearly the role preferred by the Socialists. Rebérioux preferred to present art in order for viewers "to understand" rather than "to enjoy." She used historic displays to attempt to educate the public even more about art and its role in French society. But the final museum plan was a compromise between this role and the one advocated by the curators; a compromise, as Glueck wrote, between traditional and revisionist art history.[15] With the museum trying to perform both roles, the message it sent was naturally confusing. Michael Brenson criticized, "[The Orsay] is not terribly concerned with, or perhaps even aware of, the delicate and sometimes miraculous way great art communicates. What is sustained here is not a dialogue between art and viewer but a dialogue between viewer and art history."[16]

Conclusion

The battles over the Musée d'Orsay clearly reflect the importance of culture to the French people. Unlike the United States, France has a minister of culture. During the 1980s, Minister of Culture Jack Lang was often the most popular politician in the government. The French government spends close to 1 percent of the national budget on the creation of museums and the promotion of cultural activities throughout the country. In 1993, this translated into $41 per person in France versus $1.43 per person in

the United States.[1] As Stanley Katz of the Woodrow Wilson School at Princeton University wrote about the United States:

> [T]o have no policy is to have a policy. That we do not have a national cultural policy, in other words, means that we have made a decision . . . to leave to private and local institutions the determination of the decisions most overtly affecting the creation and conduct of cultural institutions.[2]

The Orsay sends one clear message about what the state has accomplished. The Musée d'Orsay displays over 68,000 works of art, including one hundred more paintings than the Louvre. It draws an average of ten thousand visitors per day, receiving more than four million visitors during its first year. Art critic Robert Hughes noted that the Musée d'Orsay "shows what state patronage can do. Nothing that private patronage could summon up, in or out of France, could possibly rival it."[3]

In contrast, museums in the United States are private—"private in the source of their funds, private in their control, and private even in the sense that their senior staff was drawn from a privileged social class."[4] While many American museums receive support from the government, the majority were started with private funds and private collections. Even if museums receive money from the local or federal government, they operate primarily on private endowments and are governed by private boards of trustees. As Perry Rathbone writes, "It would be hard to overestimate the importance of the private collector in the life of the American art museum."[5]

French museums, on the other hand, are heavily supported by the government. French museums do not have the trustee system as do those in the United States and they need to do much

less corporate fundraising. As Françoise Cachin explains, "I think it's important that choices about exhibitions and purchases come from professionals [curators or art historians], and not for show business, profit or other reasons. It's often upside down in the United States."[6]

An examination of the difference in museum systems between the United States and France leads to two conclusions. First, the creation of an American museum such as the Orsay would be close to impossible. New major art museums in the United States come from millionaires not from the government. Referring to Mitterrand's $6 billion building program for Paris, David Lawday comments, "If this were America, Congress would still be haggling over the opera-house staircase. State architectural sprees do not happen in America."[7] Second, the French government and its people prefer that the government as well as its bureaucracy convey values about art and society. Although the messages in the Orsay appear mixed and sometimes contradictory, the museum itself attempts to provide a clear interpretation of the past.

The story of the creation of the Musée d'Orsay is a story of how the elite appropriated the nineteenth-century art necessary for a museum that serves both the elite and the masses. The outcome of the "Guerre d'Orsay" was a museum that is progressive, yet not revolutionary. Today's elite prefer the avant-garde in both art and architecture, yet they are less judgmental than their nineteenth-century counterparts of other artistic currents (such as the Impressionists) and more willing to share the elite culture with the rest of the population. The design of the museum and its collection illustrates the curators' attempts to reconcile the dichotomies of the previous century—between the avant-garde and the Salon, and the elite and the masses. The museum also reflects an attempt by all involved to reconcile the divergent roles

of the museum and demonstrates the ability of the political ri-
vals to work together. In its reappropriation of the
nineteenth-century patrimony, the Orsay conveys the values of
the late twentieth century.

Notes

Introduction

1. Quoted in numerous articles. See, for example, Jacques Rigaud, "Le Musée d'Orsay," *Atlas: Air France Magazine*, February 1987, p. 112; Alfred Borcover, "Only in Paris: Past Train Station Is Now Scene of Trips Esthetic," *Chicago Tribune*, October 23, 1988, p. C1. The actual quote is: "La Gare d'Orsay est superbe et a l'air d'un palais de Beaux-Arts et le Palais de Beaux-Arts ressemble à une gare. Je propose à Laloux de faire l'échange s'il en est temps encore." Quotations will appear in the original French when the translation does not fully do justice to it. All translations, unless otherwise noted, are the author's.

2. See Armelle Heliot, "Orsay: Le Triomphe de la Cohabitation," *Le Quotidien de Paris*, April 11, 1986; and Pierre Schneider, "Orsay: Le Musée des Cohabitations," *L'Express,* November 28, 1986, p. 115.

3. Michael Brenson, "When Artists Get Lost in a Labyrinth of Context," *New York Times*, March 6, 1988, p. 37.

4. Academic art generally refers to the art approved by the French Academy and shown in the annual Salon. Of course, academic art comprises a variety of styles and artists. The term is used primarily to contrast with the Impressionists, who broke with the Academy. See Chapter 2.

5. Quoted in Denys Sutton, "The Musée d'Orsay—A New Look at Nineteenth-Century Art," *Apollo* 125, no. 301 (March 1987): 208.

6. Stephen E. Weil, "The Proper Business of the Museum," in his *Rethinking the Museum* (Washington, D.C.: Smithsonian Institution Press, 1990), 52.

Chapter 1

1. See Charlotte Ellis, "Museums Proliferate in Paris Under Mitterand's Scene," *Architecture—The AIA Journal* 75, no. 9 (September 1986): 26; and

Daralice D. Boles, "New Architecture in Paris," *Progressive Architecture* 68, no. 7 (July 1987): 70.

2. See, for example, Louis Chevalier, *The Assassination of Paris*, trans. David Jordan (Chicago: University of Chicago Press, 1994).

3. Marc Ambroise-Rendu, "Paris à l'heure du Dix-Neuvième Siècle," *Le Monde Sans Visa*, February 7, 1987, p. 20. This is part of a special section on the Musée d'Orsay.

4. Quoted in Pierre Schneider, "Europe: La Bataille des Musées," *L'Express*, August 30, 1985, p. 11.

5. See, for example, Richard Bernstein, "I. M. Pei's Pyramid: A Provocative Plan for the Louvre," *New York Times*, November 24, 1985, sec. 6, p. 66.

6. Jean Jenger, *The Metamorphosis of a Monument* (Paris: Electa-Moniteur, 1987), 60. Jenger's book is the only text on the history of the museum. He covers the creation of the museum, the architectural competitions, and the resultant building, as well as the more technical details such as construction, lighting, and air conditioning. Jenger explains the role of the Établissment Public and gives his own opinions as the moderator of most arguments.

7. John Russell, "The Man Who Reinvented the Louvre," *New York Times*, June 6, 1993, sec. 2, p. 39.

8. Jenger, *Metamorphosis of a Monument*, 65.

9. Nancy Marmer, "The New Culture: France '82," *Art in America* 70, no. 8 (September 1982): 116. Marmer goes further into Mitterrand's plans for the city and explains the impact on Paris.

10. François Chaslin, *Le Paris de François Mitterrand* (Paris: Gallimard, 1985), 27. Chaslin's is the first comprehensive book on Mitterrand's presidency.

11. Dominique Jamet, "Musée d'Orsay: L'État des Veux," *Le Quotidien de Paris*, May 30, 1986.

12. Décret n. #78-357 du 20 mars 1978, 21 mars 1978 *Journal Officiel*, p. 1230; Arrêté du 19 juillet 1978, Modalités du contrôle financier sur l'établissement public du Musée d'Orsay, 1978 *Journal Officiel*; 2 août 1978, 1978 *Journal Officiel*, p. 2979.

13. Pierre Cabanne, "Un Cimetière Monumentale de Plus," *Le Martin de Paris*, June 5, 1978. Cabanne has been one of the most partisan writers and critics on the Musée d'Orsay. It was Cabanne who first called the Musée d'Orsay the "Musée Giscard." After 1981, Cabanne changed his position and hailed the changes that the Socialists brought to the museum.

14. Deyan Sudjic, "Mitterrand's Monuments," *Sunday Times*, March 16, 1986, p. 47.

15. Postmodern architecture generally refers to a style that can combine a variety of models, forms, and materials, often with historical references. See Robert Venturi, *Complexity and Contradiction in Architecture* (New York: Museum of Modern Art, 1966).

16. Jenger, *Metamorphosis of a Monument*, 88.

17. Ibid., 87.

18. Ibid.

19. Pierre Colboc, personal interview, Paris, January 26, 1988 (hereafter cited as Colboc interview). The majority of Colboc's opinions on the building of the Musée d'Orsay and the philosophy of ACT were expressed in this interview.

20. Jean-Paul Philippon, "Transformation: Une Première Vision," *Architecture Intérieure Crée* 215 (December 1986): 41.

21. Michael Gibson, "The Musée d'Orsay: A New and Different 19th Century," *ARTnews* 86, no. 4 (April 1987): 145.

22. By "curators" I am referring to those numerous curators and art professionals on staff at the museum who represent the majority or prevailing viewpoint. Michael Laclotte and Françoise Cachin, by virtue of their leadership positions, most often presented the opinion of the curatorial staff to the Établissement Public and the media.

23. Quoted in Charles K. Gandee, "Missed Connections," *Architectural Record* 175, no. 3 (March 1987): 128.

24. Ibid.

25. Michael Vernes, "Orsay, Gare au Pluriel," *Architectural Record* 175, no. 3 (March 1987): 128.

26. Colboc interview. Colboc stated that the Établissement Public did not dissuade Aulenti from approaching them directly and he resented the Établissement's complicity.

27. Jean Jenger, "M'O Les Arbitrages," *Architecture Intérieure Crée* 215 (December 1986): 45; Jenger, *Metamorphosis of a Monument*, 159.

28. Jenger, *Metamorphosis of a Monument*, 165.

29. Colboc interview. Despite Aulenti's influence, however, the displays in the towers today remain virtually ignored by the visiting public.

30. Quoted in Leon Whiteson, "Museums to Boutiques: Italian Designer Has Wide Range of Works," *Los Angeles Times*, April 10, 1988, p. 13.

31. Jenger, *Metamorphosis of a Monument*, 162.

32. Quoted in Veronique Prat, "Avant Tout le Monde, Découvrez le Musée d'Orsay," *Le Figaro*, November 29, 1986, p. 40. See also Bruno Foucart, "Gae Aulenti à Beaubourg et à Orsay," *Art Press*, no. 97 (November 1985): 17.

33. Quoted in Odette Fillion, "M'O Les Decideurs," *Architecture Intérieure Crée* 215 (December 1986): 33.

34. Jenger, *Metamorphosis of a Monument*, 120.

35. "Le Projet d'Orsay: Entretien avec Michel Laclotte," *Le Débat*, no. 44 (March–May 1987): 14.

36. Colboc interview.

37. Quoted in Carol Vogel, "The Aulenti Uproar: Europe's Controversial Architect," *New York Times Magazine*, November 22, 1987, p. 50.

38. Krzysztof Pomian, "Orsay Tel Qu'on Voit: Entretien avec Françoise Cachin," *Le Débat*, no. 44 (March–May 1987): 57.

39. Quoted in Vogel, "The Aulenti Uproar," 50.

40. Quoted in Foucart, "Gae Aulenti à Beaubourg et à Orsay," 17.

41. Gae Aulenti, "Interview Tendancieuse d'un Visiteur," *Architecture Intérieure Crée* 215 (December 1986): 48.

42. Aulenti, "Interview Tendancieuse d'un Visiteur," 60. Many museum professionals think the use of lighting is crucial.

43. Vogel, "The Aulenti Uproar."

44. Quoted in Marion Scali, "Une Italienne à Orsay," *Libération*, January 11, 1985, p. 34. Scali was one of the few writers to delve into the impact of having an Italian architect for a French museum. She noted that the museum administration attempted to deemphasize that fact and highlighted the role of ACT to counterbalance any negative impact. There was not much written in the French press about Aulenti being a woman (although she herself talks about it in her interviews). Robert Hughes, in noting that the lack of press regarding the choice of Aulenti as architect meant that the Orsay was both directed and designed by women, stated, "The French press hardly commented on it: a real meritocracy takes sexual equality for granted." Robert Hughes, "Paris à la Mitterand," *Time Magazine*, September 18, 1989, p. 88.

45. Quoted in Vicky Elliot, "Gae Aulenti At Work: A Tale of Two Centuries," *International Herald Tribune*, October 12, 1984.

46. Quoted in Foucart, "Gae Aulenti à Beaubourg et à Orsay," 18.

47. Florence Michel, "Gae Aulenti entre Orsay et Beaubourg," *Beaux-Art Magazine*, no. 2 (May 1983).

48. Quoted in Foucart, "Gae Aulenti à Beaubourg et à Orsay," 17.

49. Geneviève Lacambre, personal interview, Paris, January 28, 1988 (hereafter cited as Lacambre interview).

50. Quoted in Veronique Berthon, "Critiques," *Architecture Intérieure Crée* 215 (December 1986): 83.

51. Quoted in Pomian, "Orsay Tel qu'on Voit," 73.

52. Vernes, "Orsay, Gare au Pluriel," 43.

53. M. C. Lorier, "Pour une Mise en Scène des Cimaises," *Techniques et Architecture*, no. 368 (October–November 1986): 40. ("Sans doute, un des rares examples ou meubles et immeuble se confondent.")

54. Paul Goldberger, "Architecture: The New Musée d'Orsay in Paris," *New York Times*, April 2, 1987, p. C21.

55. Thomas Matthews, "The Controversial Musée d'Orsay," *Progressive Architecture* 68, no. 2 (February 1987): 35.

56. Pierre Vaisse, "Le Musée d'Orsay Visité," *Architecture d'aujourd'hui* 248 (December 1986): 24. Vaisse, on the other hand, admits that he prefers ACT's plan of a winter garden and labels the current style modern pastiche.

57. Prat, "Avant Tout le Monde," 39.

58. Jeanine Warnod, "Triomphe de l'Academisme," *Le Figaro*, December 4, 1986, p. 5 ("rigeur, laideur, et froideur").

59. Philip Jodidio, "Les Visages Multiples de Gae Aulenti," *Connaisance des Arts*, no. 411 (May 1986): 68; Peter Buchanan, "From Tuut-Tuut to Tutankahmun," *Architecture Intérieure Crée* 215 (December 1986): 80.

60. Quoted in Gibson, "The Musée d'Orsay," 144.

61. Gandee, "Missed Connections," 128.

62. François Loyer, "L'Architecture n'est plus Laissé en Plan," *Le Figaro*, December 4, 1986, p. 8; quoted in Anne Tremblay, "The New Temples of Art," *Macleans*, February 2, 1987, p. 83. Tremblay's article covers the building of new museums of art in Europe and their impact. In reference to the Musée d'Orsay, it examines the impact of reusing older buildings and designing new architecture for the interior.

63. Patricia Mainardi, "Postmodern History at the Musée d'Orsay," *October*, no. 41 (summer 1987): 44. Mainardi's is one of the few articles written in English that goes beyond a mere summary of the museum.

64. Pol Bury, "Les Architects Cannibales," *Le Nouvel Observateur*, January 16, 1987, p. 99.

65. Brenson, "When Artists Get Lost," 37.

66. Charles Rosen and Henri Zerner, "The Judgement of Paris," *New York Review of Books*, February 26, 1987, p. 24. This article is also referred to in a later debate between Albert Boime and Rosen and Zerner in Boime's, "The Avant-Garde and the Academy: An Exchange," *New York Review of Books*, July 16, 1987.

67. Pierre Cabanne, "Le Meilleur et Le Pire Cohabitent à Orsay," *Le Martin de Paris*, December 2, 1986, p. 27.

68. Matthews, "The Controversial Musée d'Orsay," 36; Goldberger, "Architecture," p. C21.

69. John House, "Orsay Observed," *Burlington Magazine* 29, no. 1007 (February 1987): 67.

70. Gilbert Lascault, "L'Ouverture du Musée d'Orsay," *La Quinzaine Littéraire* 476 (December 16–31): 23.

71. "Le Projet d'Orsay," 16.

72. Henri Zerner, personal interview, Paris, January 28, 1988 (hereafter cited as Zerner interview).

73. Stephen Bann, "The Musée d'Orsay: A Qualified Success." *Times Literary Supplement*, April 24, 1987, p. 440.

74. Vogel, "The Aulenti Uproar," 50.

75. Richard Bernstein, "In a City That Loves a Debate, Storms Swirl Over Its Newest Museum and Cultural Funds," *New York Times*, March 15, 1987, p. H39.

76. William Wilson, "The Pyramid That's the Talk of Paris," *Los Angeles Times*, July 2, 1989, p. 82.

Chapter 2

1. Décret n.#81-804 du 18 août 1981, modifiant le décret n.#78-387 du 20 mars portant creation de l'établissement public (musée du XIXe siècle), 23 août 1981 *Journal Officiel* 2299.

2. The Romantic art movement flourished from the late eighteenth century to the mid-nineteenth century. Romantic painters often focused on emotive landscapes and scenes of the past. In France, Géricault and Delacroix exemplified the Romantics with their rich colors, energetic brushwork, and dramatic, emotional subjects.

3. Louis-Philippe, the "Bourgeois King," began his reign in 1830. Although Louis-Philippe replaced his more conservative cousin, Charles X, on the throne, 1830 was still viewed as a partial success, yet the Second Republic did not begin until after the Revolution of 1848.

4. Jean-Jacques Lévêque, "Le Repli sur des Valeurs Sûres," *Les Nouvelles Littéraires*, April 23, 1981. See also *Le Matin de Paris* for numerous articles accusing Giscard of pretensions to royalty.

5. See artists' letters in Bernard Denvir, *The Impressionists at First Hand* (London: Thames and Hudson, 1987).

6. Fillion, "M'O Les Decideurs," 34. ("Giscard nous a génés, mais il nous a obligés à étudier au fond les données du programme.")

7. Lacambre interview.

8. Written in Laclotte's introduction to Guy Cogeval, *From Courbet to Cézanne, A New 19th Century. A Preview of the Musée d'Orsay, Paris* (Paris: Éditions de la Réunion des Musées Nationaux, 1986), 18.

9. Laura Frader, "Le Musée d'Orsay: Presenting the 19th Century," interview with Madeleine Rebérioux, in *French Politics and Society* 5, no. 3 (June 1987): 16.

10. Geneviève Breerette, "Un Entretien avec Mme. Madeleine Rebérioux," *Le Monde*, October 2, 1981, p. 22. This early interview reflects Rebérioux's desire to bring history into the museum and her goal of reflecting the social upheavals of the turn of the century.

11. Mainardi, "Postmodern History at the Musée d'Orsay," 32.

12. Charles Rosen and Henri Zerner, "Les Limites de la Révision," *Le Débat*, no. 44 (March–May 1987): 192.

13. Grace Glueck, "To Bouguereau, Art Was Strictly the Beautiful," *New York Times*, January 6, 1985, p. 27.

14. Anne Pingeot, "La Sculpture à Orsay," *Le Débat*, no. 44 (March–May 1987): 38. As an aside, Anne Pingeot became more well known in 1994 as the mother of François Mitterrand's child Mazarine.

15. Marie-Claude Genet-Delacroix, "Vies d'Artistes: Art Académique, Art Officiel, et Art Libre en France à la Fin du XIXe Siècle," *Revue d'Histoire*

Moderne et Contemporaine 33 (January–March 1986): 67. (Amounts shown are the amount calculated at the time of sale using the exchange rate at the time of sale.)

16. Pierre Vaisse, personal interview, January 20, 1988.

17. Boime, "The Avant-Garde and the Academy," 48. This article was part of a debate with Rosen and Zerner over the political and aesthetic implications of the Musée d'Orsay. Boime views *pompier* art as the art of the people in the nineteenth century, while other art historians believe academic art demonstrates the power of the state and the taste of the elite. He notes the popularity of sensationalist works by Gérôme and others and argues that such work should be shown because of its popularity with the people not because of the implications on state power in the nineteenth century.

18. Jeanine Warnod, "Orsay Inaugurée," *Le Figaro*, December 2, 1986, p. 35. ("Les grands civilisations ont toujours se fait la synthèse de la tradition et de la modernité, il ne fut pas de choix, pas de rupture.")

19. Henri Mercillon, "Painting," *Connaissance des Arts*, special issue, 1987, p. 41.

20. Quoted in Portes, "Mêler les pompiers aux Impressionistes, c'est mélanger les torchons et les serviettes," *Paris Match*, January 2, 1987.

21. A. M. O'Sullivan, "The Triumph of the Other 19th Century," *Connoisseur's World*, April 1984.

22. Jed Perl, "Whose Century Was It Anyway?" *New Republic*, November 2, 1987, p. 30.

23. Ibid., 32.

24. Waldemar Januszczak, "Small is Beautiful," *Manchester Guardian Weekly*, April 19, 1986, p. 21.

25. Rosen and Zerner, "The Judgement of Paris," 21. Rosen and Zerner further explain in their article "Les Limites de la Révision," that they definitely see a vague reactionary political side to the rehabilitation of the *pompiers*. Yet they note that the "most revealing characteristic of this rehabilitation is the lack of enthusiasm shown by most revisionist art historians for their favorite *pompiers*. All they can muster is an occasional hint that the work of such artists is not so bad as we used to think." On the other hand, one could dispute this lack of passion, given the inflammatory debate between Rosen and Zerner and Boime in Rosen and Zerner's "The Avant-Garde and the Academy."

26. See also Mainardi, "Postmodern History at the Musée d'Orsay," 52.

27. Nicole Duault, "Le Musée du XIX Siècle Change de Nom . . . et de Vocation," *France-Soir*, August 6, 1981, p. 15. Five years later, in her review of the opening of the museum, "Orsay Laisse les 'Pompiers' sur une Voie de Garage" (*France-Soir*, December 6, 1986), Duault reiterates the point that the academic art is hidden in the museum and that the modern art will triumph because of its better placement.

28. Warnod, "Triomphe de l'Académisme," 5.

29. Paul Lewis, "What's Doing in Paris," *New York Times*, April 19, 1987, sec. 10, p. 10.

30. The United States was the most important market tapped by Impressionist art dealer Paul Durand-Ruel. See Harrison and Cynthia White, "The Sociology of Career Support by the Dealer and by the Group Show," in *Impressionism in Perspective*, ed. Barbara Ehrlich White (Englewood Cliffs, N.J.: Prentice-Hall, 1978), 73. Of course, there are many other reasons why Americans, as a group, acquired so many Impressionists. The United States was home to many wealthy sophisticated art collectors who appreciated—and were able to purchase—fabulous collections of Impressionist art. This art, which focused on the bourgeoisie and urban life, had an intrinsic appeal to Americans. See Laura Meixner, *French Realist Painting and the Critique of American Society, 1865–1900* (New York: Cambridge University Press, 1995), 193ff.

31. Quoted in Mainardi, *Art and Politics of the Second Empire* (New Haven: Yale University Press, 1987), 113.

32. Robert Hughes, *Nothing If Not Critical: Selected Essays on Art and Artists* (New York: Alfred A. Knopf, 1990), 10.

33. Quoted in "Orsay en Bonne Voie," *Connaissance des Arts*, no. 399 (May 1983): 14.

34. Henri Mercillon, "Sculpture," *Connaissance des Arts*, special issue, 1987, p. 30.

35. Pomian, "Orsay Tel qu'on Voit," 63.

36. "Le Projet d'Orsay," 10. A clear distinction between the types of artists is made by Genet-Delacroix in "Vies d'Artistes."

37. "Bazille At the Birth of an Idea," in *The Impressionists at First Hand*, ed. Bernard Denvir (London: Thames and Hudson, 1987), 35.

38. Boime, "The Avant-Garde and the Academy," 48.

39. Pomian, "Orsay Tel qu'on Voit," 63.

40. Ibid., 60.

41. Lacambre interview.

42. Zerner interview.

43. Perl, "Whose Century Was It Anyway?" 30.

44. Yvan Christ, "La Culture Éclatée," *France Forum*, July 1984, p. 43.

45. Barnaby Conrad III, "From Paris with Love: A New Palace for Art Now Shines on the Seine," *Smithsonian* 17, no. 12 (March 1987), 90.

46. William Wilson, "Musée d'Orsay—Le Grand Hoot," *Los Angeles Times*, July 5, 1987, p. 88.

47. Hughes, "Out of a Grand Ruin," 88.

48. Pierre Soulages, "La Création Entre Parenthèses," *Le Nouvel Observateur*, January 16, 1987, p. 99.

49. Januszczak, "Small Is Beautiful," 21. Januszczak argues that the Jeu de

Paume, with its intimate interior, was much better for showing the Impressionist art that now was lost in the vastness of the museum. His title "Small Is Beautiful" summarizes his argument in reference to both the museum and its contents.

50. Zerner interview.

51. Mainardi, "Postmodern History at the Musée d'Orsay," 40.

52. "Le Projet d'Orsay,"14.

53. Pomian, "Orsay Tel qu'on Voit," 74.

54. Written in the introduction to Cogeval, *From Courbet to Cezanne,* 17.

55. Hughes, "Out of a Grand Ruin," 88.

56. Another argument is that, since these rooms kept more of the original station's architecture, the Salon art fit well with this style.

57. "Le Projet d'Orsay," 14.

58. House, "Orsay Observed," 69.

59. Jeanine Warnod, "Un Ensemble Beau, Fort, Intelligent," *Le Figaro*, December 4, 1986, p. 7. ("En les dissociant. Une voie royal de Manet à Matisse, une autre pour les académiques.")

60. Pomian, "Orsay Tel qu'on Voit," 66. This principle is in direct contrast to Mainardi's viewpoint. See note 5 above and accompanying text.

61. Pierre Schneider, "Orsay: le musée des cohabitations," *L'Express*, December 4, 1986, p. 117.

62. Michael Gibson, "Orsay, Le XIX Siècle Desocculté," *Architecture Interieure Crée* 215 (December 1986): 92. Notice the use of the same expression as Buffet, who complained earlier that napkins are mixed with dishcloths by the very presence of the academic art in the museum.

63. House, "Orsay Observed," 71.

64. Perl, "Whose Century Was It Anyway?" 32.

Chapter 3

1. "Entretien avec Valéry Giscard d'Estaing," *Connaissance des Arts*, no. 337 (March 1980): 44.

2. Pierre Cabanne, "Le Futur Musée du XIX Siècle, Un Projet Discutable pour une Periode Encore Plus Discutable," *Le Matin de Paris*, June 21, 1979.

3. Pierre Cabanne, "Les Aménagements du Futur Musée du XIX Siècle," *Le Matin de Paris*, November 20, 1980, p. 30. ("C'est bien le 'beau musée' souhaité par le president, ultra-traditional et de prestige.")

4. Guy Dumur, "Un President à Vie," *Le Nouvel Observateur*, September 26, 1981, p. 92 ("confort l'embourgeoisement de Paris").

5. See, for example, Justine De Lacy, "Cultivating Culture in Paris," *New York Times*, May 22, 1983, sec. 6, p. 42.

6. He also hired Aulenti to redesign the interior rooms at the Pompidou Center and later awarded her the Chevalier de la Legion d'Honneur, making her the first female architect so honored.

7. Madeleine Rebérioux, personal interview, January 25, 1988 (hereafter cited as Rebérioux interview). Rebérioux's opinions, unless otherwise noted, come from this interview.

8. Pierre Cabanne, "A Orsay, l'Art Récupère l'Histoire," *Le Matin de Paris*, January 8, 1982, p. 27. Note that by 1982, with the switch in governments and Mitterrand's support of the museum, Cabanne had become favorable to the Musée d'Orsay with his explanation that Rebérioux will bring the presence of history into the museum.

9. Maïten Bouisset, "Gare à Orsay!" *Libération*, February 18, 1985, p. 26.

10. Jean-Louis Ferrier, "Orsay le XIX Siècle Rèconcilié," *Le Point*, no. 741 (December 1, 1986): 79.

11. Rebérioux interview.

12. Frader, "Le Musée d'Orsay," 20.

13. Breerette, "Un Entretien avec Mme. Madeleine Rebérioux," 22.

14. Georges Beck, personal interview, January 29, 1988.

15. Madeleine Rebérioux, "Où est l'Histoire? A la Périphérie," *Le Nouvel Observateur*, no. 1158 (January 16, 1987), 100.

16. Frader, "Le Musée d'Orsay," 18.

17. Rebérioux interview.

18. Linda Nochlin, "Successes and Failures at the Orsay Museum: Or What Ever Happened to the Social History of Art," *Art in America*, January 1988, p. 88.

19. Lacambre interview.

20. Dominique Ponau, personal interview, Paris, January 26, 1988 (hereafter cited as Ponau interview).

21. Pomian, "Orsay Tel qu'on Voit," 65.

22. Françoise Cachin, "Les Réponses de Françoise Cachin," *Le Nouvel Observateur*, no. 1158 (January 16, 1987): 100–101.

23. Quoted in Emmanuel De Roux, "L'Oeil Souverain," *Le Monde Sans Visa*, November 29, 1986, p. 27. ("Le musée entier est une leçon d'histoire.")

24. House, "Orsay Observed," 72.

25. Jean Jenger, personal interview, Paris, January 25, 1988.

26. Quoted in Lynne Thornton, "A New Museum in an Old Railway Station," *The Connoisseur* 203, no. 815 (January 1980): 67.

27. Madeleine Rebérioux, "Histoire et Musée," *Le Mouvement Social*, no. 139 (April 6, 1987): 3.

28. Ferrier, "Orsay, Le XIX Siècle Réconcilié," 79.

29. Pierre Bourdieu and Alain Darbel, *L'Amour de l'Art* (Paris: Les Éditions des Minuit, 1966), 72. Although this book is over thirty years old, it is still cited

as one of the major references necessary for understanding the relationship between the French population and their museums. Written before the creation of either the Pompidou Center or the Musée d'Orsay, it provides guidelines, seen in the creation of both museums, for attracting and educating the French public.

30. Rebérioux interview.

31. Madeleine Rebérioux, "L'Histoire au Musée," *Le Débat*, no. 44 (March–May 1987): 53. ("C'est un force admirable de la museologie quand elle prend l'histoire à bras le corps. Pourquoi s'arrêter dès lors comme à mi-chemin?")

32. House, "Orsay Observed," 71.

33. Grace Glueck, "Clashing Views Reshape Art History," *New York Times*, December 20, 1987, sec. 2, p. 22. Glueck's is one of the few articles that actually addresses the different approaches to teaching art history. Glueck states that while the goal of the Musée d'Orsay was to place art in its historic context, the outcome was a compromise. This compromise has been mirrored in many art history departments where both revisionist and traditional professors teach.

34. Daniel Sherman, "The Bourgeoisie, Cultural Appropriation, and the Art Museum in Nineteenth-Century France," *Radical History Review* 38 (1987): 38–58.

35. Jenger, *Metamorphosis of a Monument*, 141.

36. Jacques Rigaud, *La Culture Pour Vivre* (Paris: Gallimard, 1975), 206. Written while Rigaud was still in the Ministry of Culture, this book explains how culture must be brought to the people. He strongly supported Rebérioux in her quest to bring history to the museum.

37. Décret n# 79-355 du 7 mai 1979, 8 mai 1979 *Journal Officiel*, p. 1080.

38. Pierre Emmanuel, *Culture, Noblesse au Monde: Histoire d'une Politique* (Paris: Stock, 1980), 10.

39. Frader, "Le Musée d'Orsay," 20.

40. Établissement Public du Musée d'Orsay, *Orsay '86: Un Musée Nouveau* (Paris: Boucky, 1983), 56.

41. Ponau interview. Ponau explained that curators are trained to be experts in every area of museology so that they can understand both the architecture of a museum as well as the display of the art. He noted, however, that curators lack knowledge of the cultural services of a museum because such training is not officially offered at the École du Louvre and, therefore, curators would be wary of innovations in this area.

42. Bourdieu, *L'Amour de l'Art*, 74.

43. Michel de Certeau, *La Culture au Pluriel* (Paris: Christien Bourgeois Éditeur, 1980), 159. In his book, Certeau outlines the various ways that the public can be reached, which include both a widening of the definition of culture and educating more of the public in the elite culture.

44. Madeleine Rebérioux, "Le Musée d'Orsay et l'Enseignement de l'Histoire," *Historiens et Geographes*, no. 293 (January 1984).

45. For public opinion of the Louvre, see polls cited in Bourdieu, *L'Amour de l'Art*, 70–77.

46. Renaud Matignon, "1500 Élèves au Musée: L'Enfance de l'Art," *Le Figaro*, December 9, 1986, p. 40.

47. "Entretien avec Valéry Giscard d'Estaing," *Connaissance des Arts*, 44.

48. Rebérioux interview.

49. Augustin Girard with Geneviève Gentil, *Cultural Development: Experiences and Policies* (Paris: UNESCO,1983), 70.

50. Rapport du Groupe Long Terme Culture, *L'Impératif Culturel*, (Paris: La Documentation Française, 1983), 79. This report was commissioned by the Ministry of Culture to examine overall policy and recommend changes to the government.

51. Rapport du Groupe Long Terme Culture, *L'Impératif Culturel*, 38.

52. When asked to define art, Andy Warhol reportedly replied, "Art? I don't believe I've met the man."

53. Pomian, "Orsay Tel qu'on Voit," 61.

54. See Claude Libert, "Regrouper, Acquérir, Compléter," *Le Figaro*, December 4, 1986, p. 11, for more on the acquisition policy of the museum.

55. Jean-François Chevrier, "Du Document à l'Oeuvre d'Art," *Le Figaro*, December 4, 1986, p. 11.

56. Quoted in Raoul Ergmann, "The Orsay Concept," *Connaissance des Arts*, special issue, 1987, p. 7. Of course, the Jeu de Paume was a museum of *French* art. The difference is that the Musée d'Orsay staked out a claim to represent more than French art.

57. Jenger, *Metamorphosis of a Monument*, 148.

58. Lascault, "L'Ouverture du Musée d'Orsay," 23.

Chapter 4

1. Carol Duncan, "Art Museums and the Ritual of Citizenship," in *Exhibiting Cultures,* ed. Ivan Karp and Steven D. Levine (Washington, D.C.: Smithsonian Institution Press, 1991), 102; Jacques Thuillier, "De la Gare au Musée," *Revue de l'Art* (December 1986): 11.

2. Stephen Weil, "An Inventory of Art Museum Roles," in his *Beauty and the Beasts: On Museums, Art, the Law and the Market,* (Washington, D.C.: Smithsonian Institution Press, 1983), 37.

3. Laura Stewart, "Salon Makeover in the Salerooms," *Daily Telegraph*, February 15, 1997, p. 6. See also Geraldine Norman, "Art Market: Collecting on a Monumental Scale," *The Independent*, May 22, 1994, p. 70.

4. Peter Slatin, "In the Shadow of the Impressionists," *Forbes*, May 30, 1988, p. 302.

5. Susan Vogel, "Always True to the Object, in our Fashion," in *Exhibiting Cultures*, ed. Ivan Karp and Steven D. Levine (Washington, D.C.: Smitsonian Institution Press, 1991), 200.

6. Brenson, "When Artists Get Lost," 40.

7. Mainardi, "Postmodern History at the Musée d'Orsay," 37.

8. James Markham, "For the Bastille, Very French Fireworks," *New York Times*, January 23, 1989, p. C19.

9. Sherman E. Lee, *Past, Present, East and West* (New York: G. Braziller, 1983), 24.

10. Beverly Wolff, "The Samuel Rubin Forum—Arts Funding and Censorship: The Helms Amendment and Beyond," *Columbia-Volunteer Lawyers for the Arts Journal of Law and the Arts* 15 (fall 1990): 27–28.

11. Weil, "An Inventory of Art Museum Roles," 35ff.

12. Jo Ann Lewis, "Getting Art on Track at Paris' New Musée d'Orsay," *Washington Post*, July 10, 1988, p. G1.

13. Weil, "An Inventory of Art Museum Roles," 35.

14. The Barnes Foundation was established in 1922 by eccentric art collector Albert C. Barnes to house his exceptional collection, which contained 800 paintings and 200 sculptures, including approximately 170 Renoirs, 55 Cézannes and 20 Picassos. The collection was open by appointment only and, even after Barnes' death and a court battle over the foundation's tax-exempt status, the galleries were only open to the public on a limited basis. The director of the foundation spent months in court breaking the foundation's charter, which stipulated that no picture could ever be lent or sold, in order that the collection could go on a world tour in 1993.

15. Grace Glueck, "Clashing Views Reshape Art History," *New York Times*, December 20, 1989, p. 22.

16. Brenson, "When Artists Get Lost," 40.

Conclusion

1. See John Rockwell, "French Culture Under Socialism: Egotism or a Sense of History," *New York Times*, March 24, 1993, p. C15.

2. Stanley N. Katz, "Influences on Public Policies in the United States," in *The Arts and Public Policy in the United States*, ed. W. McNeil Lowry (Englewood Cliffs, N.J.: Prentice-Hall, 1984), 36.

3. Robert Hughes, "Out of a Grand Ruin, A Great Museum," *Time Magazine*, December 8, 1986, p. 88. Daniele Heymann concurs in "Only the State Could Create an Orsay," *Manchester Guardian Weekly*, December 14, 1986, p. 14. Note that the two authors who remark on the role of the government are from the United States and Great Britain, where government does not play such a large role in culture.

4. Stephen Weil, "The Multiple Crises in Our Museums," in his *Beauty and the Beasts: On Museums, Art, the Law and the Market* (Washington, D.C.: Smithsonian Institution, 1983), 4.

5. Perry Rathbone, "Influences of Private Patron: The Art Museum as an Example," *The Arts and Public Policy in the United States*, ed. W. McNeil Lowry (Englewood Cliffs, N.J.: Prentice-Hall, 1984), 51.

6. Lewis, "Getting Art on Track at Paris' New Musée d'Orsay."

7. David Lawday, "Paris is Finished," *Atlantic Monthly*, August 1995, p. 22.

Bibliography

Books and Chapters

Bourdieu, Pierre, and Alain Darbel. *L'Amour de l'Art*. Paris: Les Éditions de Minuit, 1966.

Certeau, Michel de. *La Culture au Pluriel*. Paris: Christian Bourgeois Éditeur, 1980.

Chaslin, François. *Le Paris de François Mitterrand*. Paris: Gallimard, 1985.

Chevalier, Louis. *The Assassination of Paris*, trans. David Jordan. Chicago: University of Chicago Press, 1994.

Clark, T. J. *The Image of the People*. Princeton: Princeton University Press, 1982.

Cogeval, Guy. *From Courbet to Cézanne, A New 19th Century. Preview of the Musée d'Orsay, Paris*. Paris: Éditions de la Réunion des Musées Nationaux, 1986.

Denvir, Bernard, ed. *The Impressionists at First Hand*. London: Thames and Hudson, 1987.

Domenack, Jean-Marie. "Les Intellectuals et le Pouvoir." In *Société et Culture de la France Contemporaine*, ed. Georges Santon, 363–72. Albany: State University of New York Press, 1981.

———. "Le Monde des Intellectuals." In *Société et Culture de la France Contemporaine*, ed. Georges Santon, 321–49. Albany: State University of New York Press, 1981.

Duncan, Carol. "Art Museums and the Ritual of Citizenship." In *Exhibiting Cultures*, ed. Ivan Karp and Steven D. Levine, 102. Washington, D.C.: Smithsonian Institution, 1991.

Emmanuel, Pierre. *Culture, Noblesse au Monde: Histoire d'une Politique*. Paris: Stock, 1980.

Établissement Public du Musée d'Orsay. *Orsay '86: Un Musée Nouveau.* Paris: Boucky, 1983.

Girard, Augustin, with Geneviève Gentil. *Cultural Development: Experiences and Policies.* Paris: UNESCO, 1983.

Hoffmann, Stanley. "Transformations et Contradictions de la Ve Republique." In *Société et Culture de la France Contemporaine,* ed. Georges Santon, 263–86. Albany: State University of New York Press, 1981.

Honour, Hugh. *Romanticism.* New York:: Harper and Row, 1979.

Hudson, Kenneth. *Museums of Influence.* Cambridge: Cambridge University Press, 1987.

Hughes, Robert. *Nothing If Not Critical: Selected Essays on Art and Artists.* New York: Alfred A. Knopf, 1990.

Jenger, Jean. *The Metamorphosis of a Monument.* Paris: Electa-Moniteur, 1987.

Katz, Stanley N. "Influences on Public Policies in the United States." In *The Arts and Public Policy in the United States,* ed. W. McNeil Lowry, 23. Englewood Cliffs, N.J.: Prentice-Hall, 1984.

Lee, Sherman E. *Past, Present, East and West.* New York: G. Braziller, 1983.

Mainardi, Patricia. *Art and Politics of the Second Empire.* New Haven: Yale University Press, 1987.

Meixner, Laura. *French Realist Painting and the Critique of American Society, 1865–1900.* New York: Cambridge University Press, 1995.

Ministère de la Culture. *Catalogue Sommaire Illustré des Nouvelles Acquisitions du Musée d'Orsay, 1980–1983.* Paris: Éditions de la Réunion des Musées Nationaux, 1986.

Nochlin, Linda. *Realism.* New York: Penguin Books, 1971.

Pool, Phoebe. *Impressionism.* London: Thames and Hudson, 1967.

Porter, Melinda Camber. *Through Parisien Eyes: Reflections on Contemporary French Arts and Culture.* Oxford: Oxford University Press, 1986.

Rapport du Groupe Long Terme Culture. *L'Impératif Culturel.* Paris: La Documentation Française, 1983.

Rathbone, Perry T. "Influences of Private Patrons: The Art Museum As an Example." In *The Arts and Public Policy in the United States,* ed. W. McNeil Lowry, 38. Englewood Cliffs, N.J.: Prentice-Hall, 1984.

Rigaud, Jacques. *La Culture Pour Vivre.* Paris: Gallimard, 1975.

Seigneur, Frédéric. *Paris Demain.* Paris: Ministère des Rélations Extérieures, 1984.

Venturi, Robert. *Complexity and Contradiction in Architecture*. New York: Museum of Modern Art, 1966.

Vogel, Susan. "Always True to the Object, in our Fashion." In *Exhibiting Cultures*, ed. Ivan Karp and Steven D. Levine, 191–204. Washington, D.C.: Smithsonian Institution, 1991.

Weil, Stephen. *Rethinking the Museum*. Washington D.C.: Smithsonian Institution, 1990.

———. *Beauty and the Beasts: On Museums, Art, the Law and the Market*. Washington, D.C.: Smithsonian Institution, 1983.

White, Harrison, and Cynthia White. "The Sociology of Career Support by the Dealer and by the Group Show." In *Impressionism in Perspective*, ed. Barbara Ehrlich White, 73. Englewood Cliffs, N.J.: Prentice-Hall, 1978.

Articles

Aboville, Sandra d'. "Un Essor Phénomenal." *Le Figaro*, December 4, 1986, p. 12.

Agulhon, Maurice. "Un Prof à Orsay." *Le Débat*, no. 44 (March–May 1987): 156–60.

Alechinsky, Pierre. "Notes sur Orsay." *Le Débat*, no. 44 (March–May 1987): 161–63.

Ambroise-Rendu, Marc. "Paris à l'Heure du Dix-Neuvième Siècle." *Le Monde Sans Visa*, Feburary 7, 1987, p. 20.

———. "Jacques Chirac: L'Héritage Sera Lourd." *Le Monde Aujourd'hui*, March 24, 1985, p. 10.

Amery, Colin. "Musée d'Orsay: Grand Temple of Our Time." *Financial Times*, December 8, 1986, p. 13.

Anargyros, Thomas. "Orsay: Un Musée Plein de Bonnes Manières." *L'Événement de Jeudi*, November 29, 1984, p. 104.

Andraes, Christopher. " Musée d'Orsay." *The Christian Science Monitor*, December 15, 1986, pp. 27 and 30.

Arikha, Avigdor. "À Propos de la Lumière." *Le Débat*, no. 44 (March–May 1987): 164–66.

Arthur, Alan G. "The Orsay Arrives." *The Chicago Tribune*, January 11, 1987.

Aulenti, Gae. "Interview Tendancieuse d'un Visiteur." *Architecture Intérieure Crée* 215 (December 1986): 48–61. Translated as "Tendencious

Interview with a Visitor of the Musée d'Orsay," *Architecture and Urbanism*, no. 201 (June 1987): 34–45. .

———. "Un Musée, Un Oeuvre d'Art." *Architecture d'aujourd'hui* 248 (December 1986): 12–13.

———. "Pour Moi l'Architecture des un Art Durable." *Connaissance des Arts*, no. 411 (May 1986): 71–72.

August, Marilyn. "Paris' Orsay Museum: Former Rail Station a Hit in the Art World." *The Los Angeles Times*, January 17, 1988, p. 17.

Bann, Stephen. "The Musée d'Orsay: A Qualified Success." *The Times Literary Supplement*, April 24, 1987, p. 440.

Bardon, Renaud. "The Orsay Concept." *Connaissance des Arts*, special issue, 1987, pp. 20–23.

———. "Une Gare, Un Musée." *Architecture d'aujourd'hui* 248 (December 1986): 12.

Bernstein, Richard. "In a City that Loves a Debate, Storms Swirl over its Newest Museum and Cultural Funds." *The New York Times*, March 15, 1987, p. H39.

———. "I. M. Pei's Pyramid: A Provocative Plan for the Louvre." *The New York Times*, November 24, 1985, sec. 6, p. 66.

Berthon, Veronique. "Critiques." *Architecture Intérieure Crée* 215 (December 1986): 82–85.

Boime, Albert. "The Avant-Garde and the Academy: An Exchange." *The New York Review of Books*, July 16, 1987, pp. 48–49.

Boissière, Olivier. "Jadis et Daguerre." *Architecture Intérieure Crée* 215 (December 1986): 98–101.

Boles, Daralice D. "New Architecture in Paris." *Progressive Architecture* 68, no. 7 (July 1987): 67–71.

Borcover, Alfred. "Only in Paris, Past Train Station Is Now Scene of Trips Esthetic." *Chicago Tribune*, October 23, 1988, p. C1.

Boston, Richard. "Watching the World go Stylishly By." *The Manchester Guardian Weekly*, April 19, 1987, p. 20.

Bouisset, Maïten. "Gare à Orsay!" *Libération*, February 18, 1985, p. 26.

Breerette, Geneviève. "Un Entretien avec Mme. Madeleine Rebérioux." *Le Monde*, October 2, 1981, p. 22.

Brenson, Michael. "When Artists Get Lost In a Labyrinth of Context." *The New York Times*, March 6, 1988, sec. 2, pp. 37 and 40.

Bresson, Gilles. "Le Cohabitation S'Expose à Orsay." *Libération*, December 2, 1986, p. 5.

Buchanan, Peter. "From Tuut-Tuut to Tutankhamun." *Architecture Intérieure Crée* 215 (December 1986): 80–82.

Burn, Guy. "Letter from Paris, Le Musée d'Orsay." *Arts Review* 39 (January 16, 1987): 22–23.

Bury, Pol. "Les Architectes Cannibales." *Le Nouvel Observateur*, January 16, 1987, p. 99.

C., J-P. "Une Nouvelle Politique des Musées." *Le Quotidien de Paris*, April 18, 1978.

Cabanne, Pierre. "Les Aménagements du Futur Musée du XIXe Siècle." *Le Matin de Paris*, November 20, 1980, p. 30.

———. "Un Cimetière Monumentale de Plus." *Le Matin de Paris*, June 5, 1978.

———. "Le Futur Musée du XIXe Siècle, Un Projet Discutable pour une Période Encore Plus Discutable." *Le Matin de Paris*, June 21, 1979.

———. "Le Meilleur et le Pire Cohabitent à Orsay." *Le Matin de Paris*, December 2, 1986, pp. 26–27.

———. "A Orsay, l'Art Récupère l'Histoire." *Le Matin de Paris*, January 8, 1982, p. 27.

Cachin, Françoise. "Monet ou L'Europhorie Republicaine." *Le Nouvel Observateur*, November 21, 1986.

———. "Les Réponses de Françoise Cachin." *Le Nouvel Observateur*, January 16, 1987, pp. 100–101.

Cazaux, Maurice. "Les Grands Projets Culturels de l'État Ignorent la Crise." *Le Parisien*, October 9, 1984, p. 13.

———. "Musée d'Orsay: Le Projet Nouveau est Arrivé." *Le Parisien Libère*, January 31, 1983.

Champenois, Michèle. "L'Architecture du President." *Le Monde*, September 27, 1980, p. 36.

———. "L'État Donne son Feu Vert aux Architectes du Musée d'Orsay." *Le Monde*, October 10, 1982, p. 25.

———. "Les Grands Chantiers du Septennat." *Le Monde*, October 10, 1984, p. 9.

———. "Hercule par Temps de Crise." *Le Monde Aujourd'hui*, March 24, 1985, pp. 3–4.

———. "Le Maire de Paris Approuve le Programme de Grands Travaux Décidé par le Chef de l'État." *Le Monde*, February 20, 1982.

Chaslin, François. "Progress on the Grands Projets." *Architectural Review* 153, no. 1078 (December 1986): 27–30.

Chastel, André. "Nouveaux Regards sur le Siècle Passé." *Le Débat*, no. 44 (March–May 1987): 75–84.

Chemin, Michel. "Le Musée d'Orsay Enfin à Quai." *Libération*, February 26, 1985, p. 17.

———. "Repérages Présidentiels à Orsay." *Libération*, May 29, 1986.

Chevrier, Jean-François. "Du Document à l'Oeuvre d'Art." *Le Figaro*, December 4, 1986, p. 11.

Christ, Yvan. "La Culture Éclatée." *France Forum*, July 1984, pp. 42–43.

———. "De la Gare au Musée." *Le Figaro*, December 4, 1986, p. 3.

———. "Orsay, ou le Triomphe du XIXe Siècle." *France Forum*, November–December, 1986, pp. 47–50.

"La Chronique des Arts." *Gazette des Beaux Arts* 109, no. 1417 (February 1987): 1–3.

Clair, Jean. "Le Puits et le Pendule." *Le Débat*, no. 44 (March–May 1987): 116–25.

Coignard, Jerome. "Orsay: Un Musée à la Gloire du XIXe Siècle." *Beaux-Arts Magazine*, December 1986.

Combescot, Pierre. "Françoise Cachin." *Femme*, September 1986.

———. "Gae Aulenti, Architecte." *Femme*, April 1986.

Conrad, Barnaby, III. "From Paris with Love: A New Palace for Art Now Shines on the Seine." *Smithsonian* 17, no. 12 (March 1987): 82–95.

Contal, Marie-Hélene. "Architectures, l'Éclectisme entre en Scène." *Architecture Interieure Crée* 215 (December 1986): 96–97.

———."Bilan d'un Grand Projet: Interview avec Yves Dauge." *Architecture Intérieure Crée* 215 (December 1986): 106–7.

———."Un Musée à Haute Technologie." *Architecture Intérieure Crée* 215 (December 1986): 102–5.

Corrèges, André. "L'Ivresse se Boit Lentement." *Le Figaro*, December 5, 1986, p. 33.

Cruyssmans, Philippe. "Le Musée d'Orsay." *Le Journal des Beaux-Arts.* March–April 1987.

Cuvelier, Pascaline. "Les Occasions Perdues." *Architecture d'aujourd'hui* 233 (June 1984): v–xii.

D., B. "Un Musée du XIXe à la Gare d'Orsay." *L'Aurore*, January 31, 1976.

Dagen, Philippe. "Le Musée d'Orsay sur les Rails." *Le Quotidien de Paris*, June 23, 1983.

———. "Les Pompiers Sous le Feu des Impressionistes." *Le Monde Sans Visa*, November 29, 1986, pp. 28–29.

Daix, Pierre. "Une Nécrophole et des Promesses." *Le Quotidien de Paris*, December 9, 1986.

"Dans les Ruines du Palais d'Orsay." *Architecture d'aujourd'hui* 248 (December 1986): 6–9.

Daulte, Francois. "Le Musée d'Orsay." *L'Oeil: Revue de l'Art*, no. 377 (December 1986): 30–33.

"De la Dialectique Presidentielle en Matière de Cimaise." *Architecture d'aujourd'hui* 248 (December 1986): 1–3.

Denis, Stephanie. "Il n'y Aura Pas Que la Peinture." *Le Quotidien de Paris*, August 7, 1981.

Descendre, Nadine. "Le XIXe Siècle sur les Rails." *Les Nouvelles Litteraires*, December 3, 1981.

De Roux, Emmanuel. "L'Oeil Souverain." *Le Monde Sans Visa*, November 29, 1986, p. 29.

———. "Orsay: Le Dix-Neuvième Mis à Neuf." *Le Monde Sans Visa*, November 29, 1986, p. 27.

Desgroupes, Pierre. "Peinture: Le Public Revient en Force." *Le Point*, no. 422 (October 20, 1980).

Dobbs, Michael. "Musée d'Orsay: Stunning Arrival in Paris." *The Washington Post*, December 2, 1986, pp. D1 and 11.

Dorsey, Hebe. "A New Track for an Old Depot." *The International Herald Tribune*, June 27, 1980.

Duault, Nicole. "Michel Guy Veut Humaniser le Louvre." *France-Soir*, February 26, 1987.

———. "Orsay Laisse les 'Pompiers' sur une Voie de Garage." *France-Soir*, December 6, 1986.

———. "Le Musée d'Orsay est le Musée de la Cohabitation." *France-Soir*, December 2, 1986.

———. "Le Musée d'Orsay Prend du Retard." *France-Soir*, April 29, 1982.

———. "Le Musée du XIXe Siècle Change de Nom . . . et de Vocation." *France-Soir*, August 6, 1981, p. 15.

Dufoix, Georgina. "Une Volonté Politique." *Le Monde*, August 24, 1984.

Dumur, Guy. "Un Président à Vie." *Le Nouvel Observateur*, September 26, 1981, p. 92.

———. "La Rêve Arrive en Gare." *Le Nouvel Observateur*, December 14, 1984, pp. 58–59.

Duncan, Carol, and Alan Wallach. "The Universal Survey Museum." *Art History* 3, no. 4 (December 1980): 448–69.

Duparc, Christiane et Guy Dumur. "Parce que Je Suis Amoureux de Paris: Interview avec Mitterrand." *Le Nouvel Observateur*, December 14, 1984, pp. 66–70.

Edelman, Frédéric. "Fin d'Embrouiller à Orsay." *Le Monde Aujourd'hui*, March 24, 1985.

——. "Une Gare Entre au Musée." *Le Monde Sans Visa*, November 29, 1986, p. 31.

Elliot, Vicky. "Gae Aulenti at Work: A Tale of Two Centuries." *The International Herald Tribune*, October 12, 1984.

Ellis, Charlotte. "Museums Proliferate in Paris Under Mitterand's Scene." *Architecture—The AIA Journal* 75, no. 9 (September 1986): 26.

"Entretien avec Valéry Giscard d'Estaing." *Connaissance des Arts*, no. 337 (March 1980): 40–47.

Ergmann, Raoul. "Film." *Connaissance des Arts*, special issue, 1987, p. 68.

——. "The Orsay Concept." *Connaissance des Arts*, special issue, 1987, pp. 4–13.

——. "Questions pour un Nouveau Musée." *Connaissance des Arts*, no. 418 (December 1986): 11–12.

Ferenczi, Thomas. "Les Bruits d'Orsay." *Le Figaro*, December 8, 1986, p. 28.

Fermigier, André. "La Nave Va." *Le Débat*, no. 44 (March–May 1987): 167–72.

Ferrier, Jean-Louis. "Orsay, le XIXe Siècle Réconcilié." *Le Point*, no. 741 (December 1, 1986): 75–80.

——. "Musée d'Orsay l'Invitation aux Voyages." *Le Point*, no. 624 (September 3, 1984).

Fillion, Odette. "Explication de Lieu." *Architecture Intérieure Crée* 215 (December 1986): 46.

——. "Interview: Valéry Giscard d'Estaing." *Architecture Intérieure Crée* 215 (December 1986): 31.

——. "M'O Les Décideurs." *Architecture Intérieure Crée* 215 (December 1986): 30–38.

——. "Y'a-t-il Aussi Du Designé Sur les Chantiers du President." *Architecture Intérieure Crée* (May–June 1985): 84–89.

Foucart, Bruno. "L'État C'est Tout un Art." *Le Quotidien de Paris*, November 14, 1985.

——. "Gae Aulenti à Beaubourg et à Orsay." *Art Press*, no. 97 (November 1985): 17–18.

———. "Une Passion pour le XIXe Siècle." *Beaux-Arts Magazine*, January 1987.

———. "Le Retour des Dinosaures." *Le Quotidien de Paris*, April 23, 1982.

Frader, Laura. "Le Musée d'Orsay: Presenting the 19th Century." Interview with Madeleine Rjbérioux. *French Politics and Society* 5, no. 3 (June 1987): 14–22.

Fumaroli, Marc. "L'Avant-Dernier Acte." *Le Débat*, no. 44 (March–May 1987): 173–79.

Gachet, Frédérique. "La Mal-Aimée est Courtisée." *Le Figaro*, December 4, 1986, p. 9.

Gaillard, Marc. "Le Palais d'Orsay: Musée du XIXe Siècle." *Revue de l'Habitat Français*, July 20, 1986, pp. 392–93.

Gaillemin, Jean-Louis. "Orsay Sous le Feux de la Presse." *Beaux-Arts Magazine*, January 1987.

Gandee, Charles K. "Missed Connections." *Architectural Record* 175, no. 3 (March 1987): 128–39.

Garcias, Jean-Claude, and Martin Meade. "The Politics of Paris." *Architectural Review* 153, no. 1078 (December 1986): 23–26.

Garcias, Jean-Claude, and J-J. Treuttel. "Ou en est le Musée d'Orsay?" *Techniques et Architectecture*, no. 379 (September 1979): 75–76.

Garnier, Isabelle. "Le Musée du XIXe Siècle, Le President et Moi." *Journal de Dimanche*, November 16, 1980.

Gaxotte, Pierre. "L'Art du Gaspillage." *Le Figaro*, April 12, 1980.

Genet-Delacroix, Marie-Claude. "Vies d'Artistes: Art Academique, Art Officiel et Art Libre en France à la Fin du XIXe Siècle." *Revue d'Histoire Moderne et Contemporaine* 33 (January–March 1986): 40–73.

Gibson, Eric. "Grading French Academic Art." *The Washington Times*, September 27, 1992, p. D2.

Gibson, Michael. "The Musée d'Orsay: A New and Different 19th Century." *ARTnews* 86, no. 4 (April 1987): 142–46.

———. "Orsay, le XIXe Siècle Desocculté." *Architecture Intérieure Crée* 215 (December 1986): 86–95.

———. "The Opening of the Musée d'Orsay." *The International Herald Tribune*, November 28, 1986.

"Giscard a Lui-Même Choisi les Architectes du Musée du XIXe Siècle." *Le Matin de Paris*, June 7, 1979.

"Giscard d'Estaing: Le Musée d'Orsay sera Exemplaire." *Le Figaro*, July 1977.

Glueck, Grace. "To Bouguereau, Art Was Strictly the Beautiful," *The New York Times*, January 6, 1985, p. 27.

————. "Clashing Views Reshape Art History." *The New York Times*, December 20, 1987, sec. 2, pp. 1 and 22–23.

Godet, Bernadette. " Musées du Bilan de Jack Lang." *Le Quotidien de Paris*, December 5, 1985.

————. "Tout l'Art d'Orsay." *Le Quotidien de Paris*, December 1, 1986, pp. 17–18.

Goldberger, Paul. "Architecture: The New Musée d'Orsay in Paris." *The New York Times*, April 2, 1987, p. C21

————. "In Paris, A Face Lift in Grand Style." *The New York Times*, May 17, 1987, sec. 2, pp. 1 and 42.

Goulet, Patrice. "Comment Choisir un Architecte?" *Architecture Intérieure Crée*, no. 172 (1979): 46–48.

Gouvion, Colette. "Gae Aulenti, une Reine au Musée d'Orsay." *Cent Idées*, September 1983.

Grainville, Patrick. "Fièvre et Féerie." *Le Figaro*, December 2, 1986, p. 35.

Gravelaine, Frédérique de. "Architecture: Paris Transfiguré." *L'Unité*, July 8, 1983, pp. 17–18.

Greenhouse, Steven. "Why Paris Works." *The New York Times*, July 19, 1992, p. 14.

Guegan, Stéphane. "Orsay, l'Autre Parcours." *Le Matin de Paris*, December 8, 1986.

Haskell, Francis. "The Artist and the Museum." *The New York Review of Books* 34, no. 19 (December 3, 1987): 38–42.

————. "L'Art et le Langage de la Politique." *Le Débat*, no. 44 (March–May 1987): 106–15.

Heilbrun, Françoise. "La Photographie à Orsay." *Le Débat*, no. 44 (March–May 1987): 41–47.

Heliot, Armelle. "Orsay: Le Triomphe de la Cohabitation." *Le Quotidien de Paris*, April 11, 1986.

Helleu, Claude. "Jacques Rigaud: 'Pourquoi Orsay Sera un Musée Nouveau?'" *Le Quotidien de Paris*, March 15, 1985, p. 26.

Herbert, Robert L. "Impressionism, Originality, and Laissez-Faire." *Radical History Review* 38 (1987): 7–15.

Herve, Jane. "François Mitterrand, Le Premier des Patrimoines, C'est l'Homme." *Les Nouvelles Littéraires*, May 7, 1981.

Heymann, Daniele. "Only the State Could Create an Orsay." *Manchester Guardian Weekly*, December 14, 1986, p. 14.

————. "Tableaux de Chasse." *Le Monde Sans Visa*, November 29, 1986, p. 28.

House, John. "Orsay Observed." *The Burlington Magazine* 29, no. 1007 (February 1987): 67–73.

Housego, David. "France's Renaissance." *Financial Times*, March 8, 1986, weekend section, p. 1.

Hoving, Thomas. "Pompiers and Circumstance." *Connoisseur*, September 1987.

Hughes, Robert. "Out of a Grand Ruin, a Great Museum." *Time*, December 8, 1986, pp. 84–88.

————. "Paris à la Mitterrand." *Time*, September 18, 1989, p. 88.

Hugonot, Marie-Christine. "Les Pompiers Reviennent en Fanfare." *Magazine Hebdo*, February 24, 1984.

Huser, France. "La Guerre d'Orsay." *Le Nouvel Observateur*, January 16, 1987, p. 98.

————. "Orsay: L'Art Entre en Gare." *Femme*, November 1986.

————. "Valéry Giscard d'Estaing au Pied du Mur." *Le Nouvel Observateur*, September 27, 1980, pp. 74–76.

Jamet, Dominique. "Musée d'Orsay: L'État des Veux." *Le Quotidien de Paris*, May 30, 1986.

Januszczak, Waldemar. "Small is Beautiful." *Manchester Guardian Weekly* 136, no. 16 (April 19, 1987): 21.

Jenger, Jean. "L'Étrange Histoire d'une Gare et de sa Métamorphose Architectural." *La Revue du Louvre* 36, no. 6 (1986): 355–62.

————. "M'O Les Arbitrages." *Architecture Intérieure Crée* 215 (December 1986): 42–45.

————. "Une Mutation Architecturale Paradoxale." *Le Débat*, no. 44 (March–May 1987): 20–30.

————. "The Orsay Concept." *Connaissance des Arts*, special issue, 1987, pp. 13–19.

————. "Orsay, De la Gare au Musée." *Architecture d'aujourd'hui* 248 (December 1986): 10–11.

Jodidio, Philip. "L'Ère des Musées." *Connaissance des Arts*, October 1985, p. 7.

————. "Orsay et la Presse." *Connaissance des Arts*, no. 420 (February 1987): 9–10.

————. "Les Visages Multiples de Gae Aulenti." *Connaissance des Arts*, no. 411 (May 1986): 66-70.

Kern, Henri Paul. "Le Musée d'Orsay, Futur Musée de la Création." *Le Figaro*, June 25, 1983.

———. "Un Statut de Droit Commun pour Paris." *L'Aurore*, February 20, 1982.

Kimmelman, Michael. "Forgiving the Popular Paintings." *The New York Times Book Review*, November 12, 1989, p. 20.

Kisselgoff, Anna. "Dance View: Tracing the Echoes of Mallerme's Enigmatic Faun." *The New York Times*, April 9, 1989, sec. 2, p. 7.

Kjellberg, Pierre. "Première visite à Orsay: Interview with Giscard d'Estaing." *Connaissance des Arts*, no. 337 (March 1980): 48–52.

Lachenaud, Jean-Philippe. "Orsay, Un Musée dans une Gare Monument Historique." *Monuments Historiques*, no. 104 (1979): 4–13.

Laclotte, Michel. "Le Musée de XIXe Siècle." *Monuments Historiques*, no. 104 (1979): 13–14.

———. "Réflexions sur le Program Muséographique." *La Revue du Louvre* 36, no. 6 (1986): 363–72.

"La Culture, C'est Jack Lang." *The Economist*, August 20, 1988, p. 43.

Lascault, Gilbert. "L'Ouverture du Musée d'Orsay." *La Quinzaine Littéraire* 476 (December 16–31, 1986): 23.

Laurent, Rachel. "Visite Guidée." *Art Press*, February 1987.

Lawday, David. "Paris is Finished," *The Atlantic Monthly*, August 1995, p. 22.

Le Bot, Marc. "Le Musée d'Orsay." *La Quinzaine Littéraire* 479 (February 1–15, 1987): 29.

Le Brun, Françoise. "Orsay fait Flamber les Pompiers." *Le Nouvel Economiste*, November 28, 1986.

Lebrun, Jean. "Nouvelle Orientation pour Orsay." *La Croix*, August 7, 1981.

LeCaisne, Nicole. "Les Pas Retrouvés d'Orsay." *L'Express*, September 30, 1983.

Lemoine, Bertrand. "Invitation au Voyage." *Architecture Intérieure Crée* 215 (December 1986): 62–79.

Leveque, Jean-Jacques. "Les Pompiers Contre l'Ennui." *Les Nouvelles Littéraires*, March 24, 1983.

———. "Le Repli sur des Valeurs Sûres." *Les Nouvelles Littéraires*, April 23, 1981.

Lévi-Strauss, Claude. "Le Cadre et les Oeuvres." *Le Débat*, no. 44 (March–May 1987): 180–83.

Lewis, Jo Ann. "Getting Art on Track at Paris' New Musée d'Orsay." *The Washington Post*, July 10, 1988, p. G1.

Lewis, Paul, "What's Doing in Paris." *The New York Times*, April 19, 1987, sec. 10, p. 10.

Libert, Claude. "Regrouper, Acquérir, Compléter." *Le Figaro*, December 4, 1986, p. 11.

Linguanotto, Stephanie. "Je Regrette Certaines Touches de Style: Jean Paul Philippon." *Le Figaro*, December 4, 1986, p. 4.

Lipton, Eunice, and Wanda Corn. "Musée d'Orsay: Art History vs. History." *Art in America*, no. 6 (summer 1983): 47–50.

Lismonde, Pascale. "Le Musée Entre en Gare." *Équipement Magazine*, February 1985, pp. 24–25.

Lorier, M. C. "Pour une Mise en Scène des Cimaises." *Techniques et Architecture*, no. 368 (October–November 1986): 34–43.

Loyer, Françoise. "L'Architecture n'est plus Laissée en Plan." *Le Figaro*, December 4, 1986, p. 8.

Mainardi, Patricia. "Postmodern History at the Musée d'Orsay." *October*, no. 41 (summer 1987): 31–52.

Maresse, Anne, and Michael Vernes. "Mort et Résurrection d'une Gare." *Architecture Intérieure Crée*, no. 172 (1979): 49–52.

Marest, Lucien. "La Culture 'Made in Lang.'" *La Pensée*, no. 249 (January–February 1986): 69–77.

Marmer, Nancy. "The New Culture: France '82." *Art in America* 70, no. 8 (September 1982): 115–23.

Markham, James. "For the Bastille, Very French Fireworks." *The New York Times*, January 23, 1989, p. C19.

Masson, Christine. "Orsay à l'Americaine." *Les Nouvelles Littéraires*, June 19, 1980.

Matignon, Renaud. "1500 Élèves au Musée: L'Enfance de l'Art." *Le Figaro*, December 9, 1986, p. 40.

Matthews, Thomas. "The Controversial Musée d'Orsay." *Progessive Architecture* 68, no. 2 (February 1987): 35–36.

Mazars, Pierre. "Procès en Revision d'un Siècle Unjustement Décrié." *Le Figaro*, May 21, 1978.

Meisler, Stanley. " Musée d'Orsay Tracks the 19th Century." *The Los Angeles Times*, January 3, 1987, part VI, pp. 1 and 5.

Méneval, Claude de. "L'Éclairage d'Orsay." *Lumières et Eclairages*, March–April 1987.

Mercillon, Henri. "Decorative Arts." *Connaissance des Arts*, special issue, 1987, pp. 70–72.

———. "History." *Connaissance des Arts*, special issue, 1987, p. 66.

———. "History of Architecture." *Connaissance des Arts*, special issue, 1987, p. 74.

———. "Painting." *Connaissance des Arts*, special issue, 1987, pp. 32-49.

———. "Photography." *Connaissance des Arts*, special issue, 1987, pp. 59–65.

———. "Sculpture." *Connaissance des Arts*, special issue, 1987, pp. 25–31.

———. "Vers un Politique des Musées." *Connaissance des Arts*, no. 416 (November 1986): 70–75.

Michel, Florence. "Gae Aulenti entre Orsay et Beaubourg." *Beaux-Arts Magazine*, no. 2 (May 1983).

Michel, Jacques. "Un Musée pour Resoudre les Problèmes des Musées." *Le Monde*, February 4, 1976.

Mohrt, Françoise. "Gae Aulenti: Une Dame pour une Oeuvre." *Decoration*, April 1983, pp. 57–60.

Morot-Sir, Edouard. "Vers une Conscience et une Politique Nouvelle de la Culture en France." *Contemporary French Civilization* 8, nos. 1–2 (fall–winter 1983–84): 263–93.

Mosby, Aline. "The French 'Cultural Revolution.'" *The International Herald Tribune*, March 12, 1982.

"Le Musée d'Orsay." *Revue de l'Art*, no. 50 (1980): 4–8.

"Musée d'Orsay Projets." *Profil*, May–June 1976.

Muzy, Félix. "Les Impressionistes et le Futur Musée du XIXe Siècle." *Coté des Arts*, March 1986.

Nicolin, Pierluigi. "Paris: The Musée d'Orsay." *Lotus International* 35, no. 2 (1982): 15–31.

Nochlin, Linda. "Museums and Radicals: A History of Emergencies." *Art in America* 59 (1971): 26.

———. "Successes and Failures at the Orsay Museum: Or What Ever Happened to the Social History of Art." *Art in America*, January 1988, p. 88.

Norman, Geraldine. "Art Market: Collecting on a Monumental Scale" *The Independent*, May 22, 1994, p. 70.

Nouvel, Jean. "Le Débat sur l'Architecture." *Le Nouvel Observateur*, November 24, 1980.

"1,990,947 Oeuvres d'Art et des Poussières." *Architecture d'aujourd'hui* 248 (December 1986): 4.

Ornano, Michel d'. "Nouvelle Politique des Musées." *Le Figaro*, August 11, 1977.

"Orsay et Bastille: Mitterrand a Imposé Deux Erreurs Monumentales." *Le Figaro Magazine*, March 9, 1985.

"Orsay en Bonne Voie." *Connaissance des Arts*, no. 399 (May 1983): 14.

"The Orsay Concept." *Connaissance des Arts*, special issue. December 1986, p. 23.

"Orsay: Le Dix-Neuvième Mis a Neuf." *Le Monde sans Visa*, November 29, 1986, pp. 27–31.

"Orsay . . . Le Musée de la Belle Époque." *Chantiers de France*, March 1985.

"Orsay: Un Musée Populaire." *Connaissance des Arts*, no. 357 (November 1981): 50.

O'Sullivan, A. M. "The Triumph of the Other 19th Century." *Connoisseur's World*, April 1984.

Packer, William. "Celebration on the Seine." *Financial Times*, December 2, 1986, p. 17.

———. "Turn of the Century." *Financial Times*, December 4, 1986, p. 14.

Paillard, Henri. "Nombreuses Critiques Contre le Projet de Création à Paris d'un Musée du XIXe Siècle." *Le Figaro*, May 19, 1978.

"Paris Orsay." *Patrimoine Architectual*, special issue, March 1985, pp. 37–38.

Pastinelli, Jean Yves. "De la Gare au Musée." *Architecture Intérieure Crée* 215 (December 1986): 17–20.

Paulino-Neto, Brigitte. "Valéry Giscard d'Estaing: J'Aurais Préféré une Structure Plus Légère." *Libération*, December 9, 1986, pp. 32–33.

Peppiatt, Michael. "It's Not the End of the Line for the Gare d'Orsay." *ARTnews* 79, no. 4 (April 1980): 132–35.

———. "A New Home for 19th Century French Art." *The New York Times*, October 7, 1979, pp. 31–32.

Perl, Jed. "Whose Century Was It, Anyway?" *The New Republic*, November 2, 1987, pp. 30–33.

Philippon, Jean-Paul. "Transformation: Une Première Vision." *Architecture Intérieure Crée* 215 (December 1986): 38–42.

Pigeot, Jean. "Gare d'Orsay: Une Musée du XIXe Siècle pour le XXIe." *Le Parisien*, March 7, 1984.

Pingeot, Anne. "La Sculpture Monumentale du Musée d'Orsay." *Monuments Historiques*, no. 138 (April–May 1985): 20–25.

———. "La Sculpture à Orsay." *Le Débat*, no. 44 (March–May 1987): 37–40.

Pipes, Alan. " Musée d'Orsay Saves its Image." *Design*, no. 458 (February 1987): 9.

Pognon, Olivier. "Loi Programme sur les Musées: 1.4 Milliard pour la Renovation." *Le Figaro*, April 19, 1978.

Pomian, Krzysztof. "Orsay Tel qu'on Voit: Entretien avec Françoise Cachin." *Le Débat*, no. 44 (March–May 1987): 55–74.

Portes, Florence. "La Guerre d'Orsay." *Paris Match*, January 2, 1987.

———. "Interview avec Françoise Cachin." *Paris Match*, December 5, 1986.

Potel, Jean-Yves. "Des Grands Travaux À la Memoire de la Gauche Triomphante." *Les Temps Modernes*, February 1986, pp. 44–57.

Poulain, Isabelle. "Le Musée d'Orsay." *Coulisse, Internationale.* (fall–winter 1986–87).

Pousse, J.-F. "Le Temps du Musée." *Techniques et Architecture*, no. 368 (October–November 1986): 20–33.

Powell, Nicholas. "The Musée d'Orsay in Paris." *Art and Auction*, June 1984, pp. 70–72.

Pradel, Jean-Louis. "Ce Que Vous Allez Voir au Musée d'Orsay." *L'Événement du Jeudi*, November 20–26, 1986, pp. 88–97.

Prat, Veronique. "Avant Tout le Monde, Découvrez le Musée d'Orsay." *Le Figaro*, November 29, 1986, pp. 38–42.

———. "La Bizarre Querelle du Musée d'Orsay." *Le Figaro Magazine*, March 15, 1980, pp. 90–92.

"Le Projet d'Orsay: Entretien avec Michel Laclotte." *Le Débat*, no. 44 (March–May 1987): 4–19.

"Quand les Académiques Étaient Aussi des Coquins." *Le Figaro Magazine*, September 27, 1986.

Quirot, Odile. "Aiguilleurs Culturels." *Le Monde Sans Visa*, November 29, 1986, p. 30.

Rebérioux, Madeleine. "Histoire et Musée." *Le Mouvement Social*, no. 139 (April–June 1987): 3–5.

———. "L'Histoire au Musée." *Le Débat*, no. 44 (March–May 1987): 48–54.

———. "Le Musée d'Orsay et l'Ensignement de l'Histoire." *Historiens et Geographes*, no. 293 (January 1984).

———. "Où est l'Histoire? A la Périphérie." *Le Nouvel Observateur*, no. 1158 (January 16, 1987): 100.

Reif, Rita. "D'Orsay Displays Design's Elite." *The New York Times*, July 24, 1988, sec. 2, p. 30.

Revel, Jean François. "Modeste Proposition." *Le Débat*, no. 44 (March–May 1987): 184–87.

Rheims, Francine. "Du Pastiche à l'Inédit." *Le Figaro*, December 4, 1986, p. 10.

Richard, Pascale. "Orsay, Musée du XIXe Siècle." *Le Quotidien de Paris*, January 31, 1987.

Riding, Alan. "Does Art Have to be Popular? Barcelona Debates a Huge Sock." *The New York Times*, March 24, 1992, p. C11.

Rigaud, Jacques. "La France a-t-elle une Politique du Patrimoine?" *Études*, December 1985, pp. 615–25.

———. "Le Musée d'Orsay." *Atlas, Air France Magazine*, February 1987, pp. 109–20.

———"Réflexions d'un Administrateur." *Le Débat*, no. 44 (March–May 1987): 31–36.

Rockwell, John. . . . *And Intellectuals Rally to the Cause. The New York Times*, September 13, 1992, p. 5.

Roegier, Patrick. "Honneur aux 'Primitifs' de la Photo." *Le Monde Sans Visa*, November 29, 1986, p. 30.

Rosamel, Chantal de. "Gae Aulenti: Le Design Pur et Dur." *Le Figaro* 144, no. 13 (December 4, 1986): 4.

Rose, Barbara. "Amazing Space." *Vogue*, February 1987, pp. 394–97 and 457.

Rosen, Charles, and Henri Zerner. "The Avant-Garde and the Academy: An Exchange." *The New York Review of Books*, July 16, 1987, pp. 48–49.

———. "The Judgment of Paris." *The New York Review of Books*, February 26, 1987, pp. 21–25.

———. "Les Limites de la Révision." *Le Débat*, no. 44 (March–May 1987): 188–92.

Rosenblum, Robert. "Reconstruire la Peinture du XIXe Siècle." *Le Débat*, no. 44 (March–May 1987): 85–89.

Rossant, John. "Vive la Culture—Especially When It Pays Off in Francs." *Business Week*, December 6, 1985.

Roud, Richard. "One Station Along the Road to History." *The Guardian*, April 14, 1980, p. 9.

Roux-Dorlut, Maya. "Orsay: La Ville dans le Musée, le Musée dans la Ville." *Architectes*, January 1984, pp. 18–19.

Russell, John. "Encyclopedic Museum: Reviewing the Orsay." *The New York Times*, December 4, 1986, pp. A1 and C18.

———. "From Lopsidedness to Limpidity: A Rethought and Renewed Taste." *The New York Times*, February 14, 1990, p. C13.

———. "Is Impressionism Too Popular for Its Own Good?" *The New York Times*, February 2, 1986, sec. 2, pp. 1 and 25.

———. "The Man Who Reinvented the Louvre." *The New York Times*, June 6, 1993, sec. 2, p. 39.

———. "Paris Evokes a Golden Past in a Restored Train Station." *The New York Times*, December 14, 1986, sec. 2, pp. 37 and 42.

Salgas, Jean-Pierre. "Le Musée d'Orsay? Ni Gare de Départ ni Terminus mais Salle des Pas Perdus." *La Quinzaine Littéraire* 477 (January 1–15, 1987): 16–17.

Scali, Marion. "Une Italienne à Orsay." *Libération*, January 11, 1985, p. 34.

Schaer, Roland. "The Cultural Service." *Connaissance des Arts*, special issue, 1987, pp. 50–53.

Schmitt, Olivier. "Jack Lang: Trop Ambitieux? Non, Pas Assez!" *Le Monde Aujourd'hui*, March 24, 1985, p. 10.

Schneider, Pierre. "Europe: La Bataille des Musées." *L'Express*, August 30, 1985, pp. 6–11.

———. "Gare d'Orsay on Its Way to Being a Museum." *The New York Times*, July 17, 1980, p. C14.

———. "Orsay: Le Musée des Cohabitations." *L'Express*, November 28, 1986.

Scott, Barbara. "Music at the Musée d'Orsay." *Apollo* 125, no. 302 (April 1987): 302–4.

Sherman, Daniel J. "The Bourgeoisie, Cultural Appropriation, and the Art Museum in Nineteenth Century France." *Radical History Review* 38 (1987): 38–58.

Slatin, Peter. "In the Shadow of the Impressionists," *Forbes*, May 30, 1988, p. 302.

Sompairac, Arnaud. "Le Monde d'Orsay." *Monuments Historiques*, no. 148 (December 1986): 101–8.

Soulages, Pierre. "La Création Entre Parenthèses." *Le Nouvel Observateur*, January 16, 1987, pp. 98–99.

Stewart, Laura. "Salon Makeover in the Salerooms," *The Daily Telegraph*, February 15, 1997, p. 6.

Strand, John. "Waiting for the Renaissance." *Passion*, April 1983, pp. 10–11.

Sudjic, Deyan. "Mitterrand's Monuments." *The Sunday Times*, March 16, 1986, p. 47.

Sutton, Denys. "The Musée d'Orsay—A New Look at Nineteenth Century Art." *Apollo* 125, no. 301 (March 1987): 206–15.

Sylvestre, Jean-Marc. "Jacques Rigaud: Il faut Developper le Concept d'Enterprises Culturelles." *Le Quotidien de Paris*, November 8, 1985.

Tacchella, Jean-Charles. "Un Cinéaste Émerveillé." *Le Figaro*, December 8, 1986.

Tasset, Jean-Marie. "Pourquoi Orsay?" *Le Figaro*, December 4, 1986, p. 2.

Thaw, E. V. "The Museum Transformed: Design and Culture in the Post-Pompidou Age" (book review). *The New Republic*, March 30, 1992, p. 13.

Thornton, Lynne. "A New Museum in an Old Railway Station." *The Connoisseur* 203, no. 815 (January 1980): 66–68.

Thuillier, Jacques. "De la Gare au Musée." *Revue de l'Art*, no. 74. December 1986, pp. 5–11.

"The Train Station becomes a Major Museum." *Neue Zürcher Zeitung*, Zurich in the *World Press Review*, February 1987, pp. 61–62.

Tremblay, Anne. "The New Temples of Art." *Macleans*, February 2, 1987, pp. 82–83.

Vaisse, Pierre. "Autour d'Orsay, Musée de Toute une Époque." *Art Press*, no. 97 (November 1985): 18–20.

———. "Le Dialogue Renoué." *Le Figaro*, December 4, 1986, p. 7.

———. "L'Esthétique XIXe Siècle: de la Légende aux Hypothèses." *Le Débat*, no. 44 (March–May 1987): 90–105.

———. "Le Musée d'Orsay Visité." *Architecture d'aujourd'hui* 248 (December 1986): 24–25.

———. "Le XIXe Siècle dans les Livres." *Le Figaro*, December 4, 1986, p. 13.

———. "Le Temple de l'Art du Temps." *Le Figaro*, December 4, 1986, p. 6.

Venries, Patrick. "Le XIXe Siècle Mis en Banque." *La Dépêche du Midi*, October 25, 1986.

Vernes, Michael. "Orsay, Gare au Pluriel." *Architectural Record* 175, no. 3 (March 1987): 128.

———. "Orsay, Gare au Pluriel." *Architecture Intérieure Crée*, no. 189 (October 1982): 34–43.

———. "Orsay-Terminus et Memorial." *Architecture Intérieure Crée* 215 (December 1986): 4–30.

"Vers un Autre XIXe Siècle." *Le Débat*, no. 44 (March–May 1987): 3.

Vincendon, Sibylle. "Le Musée d'Orsay Entre deux Quais." *Libération*, June 24, 1983, p. 16.

Vogel, Carol. "The Aulenti Uproar: Europe's Controversial Architect." *The New York Times Magazine*, November 22, 1987, pp. 26–32 and 50–54.

Volta, Ornella. "Le Musée Selon Gae Aulenti." *Vogue*, November 1984, pp. 306–7.

Vuilleumier, Jean-Pierre. "Museum Programming and Development Policy." *Museum* 32, no. 2 (1983): 94–97.

Warnod, Jeanine. "Un Ensemble Beau, Fort, Intelligent." *Le Figaro*, December 4, 1986, p. 7.

———. "Orsay Inaugurée." *Le Figaro*, December 2, 1986, p. 35.

———. "Triomphe de l'Academisme." *Le Figaro*, December 4, 1986, p. 5.

Whiteson, Leon. "Museums to Boutiques, Italian Designer Has Wide Range of Works." *The Los Angeles Times*, April 10, 1988, p. 13.

Wilson, William. "Making Book on the Now-Familiar Post-Mod." *The Los Angeles Times*, May 1, 1988, p. 3.

———. "Musée d'Orsay—Le Grand Hoot." *The Los Angeles Times*, July 5, 1987, p. 88.

———. "The Pyramid That's the Talk of Paris," *The Los Angeles Times*, July 2, 1989, p. 82.

Wolff, Beverly. "The Samuel Rubin Forum—Arts Funding and Censorship: The Helms Amendment and Beyond." *Columbia-Volunteer Lawyers for the Arts Journal of Law and the Arts* 15 (fall 1990): 23–41.

Xenakis, Iannis. "Ma Visite à Orsay." *Le Figaro*, December 4, 1986.

Yeru, Henri. "Orsay ou le Temps Retrouvé." *Études*, January 1987.

Zad, Martie. "The Family Channel's 'Peter Rabbit.'" *The Washington Post*, March 28, 1993, p. Y7.

French Government Documents

Décret n# 78-357 du 20 mars 1978, 21 mars 1978 *Journal Officiel,* p. 1230 (establishing the Établissement Public).

Décret n# 79-355 du 7 mai 1979, 8 mai 1979 *Journal Officiel,* p. 1080.

Décret n# 81-804 du 18 août 1981 modifiant le décret n# 78-387 du 20 mars 1978 portant création d'un établissement public (musée du XIXe siècle), 23 aout 1981 *Journal Officiel*, p. 2299.

Arrêté du 19 juillet 1978, Modalités du contrôle financier sur l'établissement public du Musée d'Orsay, 2 août 1978 *Journal Officiel*, p. 2979.

Arrêté du 23 octobre 1979, Direction des Musées de France, 18 novembre 1979 *Journal Officiel*, p. 9375 numéro complementaire (discussing the goals of the administration of all French museums).

Arrêté du 14 janvier 1982, Designation de personnes responsables des marches, 28 janvier 1982 *Journal Officiel*, p. 1086 numéro complementaire.

Arrêté du 14 mars 1985, Fixant les pouvoirs de la mission de controle des organismes charges de la réalisation des grandes operations d'architecture et d'urbanisme et les modalités de ce contrôle en ce qui concerne les établissements publics du Musee d'Orsay, de l'Opera de la Bastille et du Grand Louvre, 28 mars 1985 *Journal Officiel*, p. 3617.

Ministry of Culture and Communication. *Agence France Presse*. 1976–88.

———. *Lettre d'Information*. October 1987–January 1988

———. *Lettre Internationale*. 1988

———. *Musées de France*. January 1988.

———. *Notes sur le* Musée d'Orsay. November 21, 1986.

———. *Orientations Budgetaires pour 1988*. October 8, 1987.

———. *La Politique Culturelle 1981–1985: Bilan de la Législature*. Les Musées.

———. *Présentation du Budget de la Communication*. November 6, 1987.

———. *Présentation du Budget de la Culture*. October 30, 1987.

Ministry of the Interior. *Les Moniteux des Travaux Publics*.

Préfecture de la Région Île de France. *Semaine de l'Ile de France*. 1976–88.

Interviews (all in Paris, 1988)

M. Georges Beck, Conseiller Technique to Jack Lang, Former Minister of Culture. January 29, 1988.

Mme. Michèle Champenois, journalist for *Le Monde*. January 29, 1988.

M. Pierre Colboc, architect and partner in ACT Architecture. January 26, 1988.

M. Jean Coural, Director of Mobilier National. January 27, 1988.

M. Jean Jenger, Director of Documentation Française and former Director of the Établissement Public of the Musée d'Orsay. January 25, 1988.

Mme. Geneviève Lacambre, Head Curator of the Musée d'Orsay. January 28, 1988.

Mme. Mariani-Ducray, Conseiller Technique in charge of national museums to François Leotard, Minister of Culture. January 29, 1988.

M. George Monni, Cultural Service of the Musée d'Orsay. January 25, 1988.

M. Dominique Ponau, Director of the École du Louvre and of the École du Patrimoine. January 26, 1988.

Mme. Madeleine Rebérioux, Former Vice-President of the Établissement Public of the Musée d'Orsay. January 25, 1988.

M. Pierre Vaisse, professor and art historian at University of Paris X. January 20, 1988.

M. Henri Zerner, professor and art historian at Harvard University. January 28, 1988.

Index